Marc Chagall

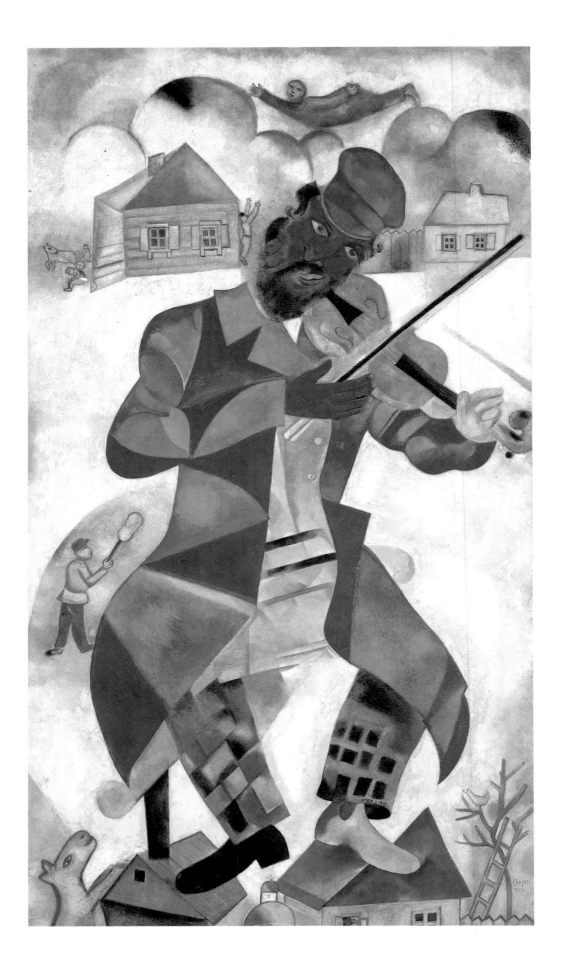

MODERN MASTERS SERIES

Marc Chagall

Andrew Kagan

ABBEVILLE PRESS · NEW YORK

Marc Chagall is volume 13 in the Modern Masters series.

ACKNOWLEDGMENTS: The author thanks Philip Samuels and the staff of Philip Samu-els Fine Art for gracious and generous assistance; Michael Rubin for invaluable dialogue and insight; Esther Gerber, for the gift of ideas; Kathleen McNally, CEB, for being so; Richard Martin and Lawrence D. Steefel, Jr., for unfailing moral support; and Jayne Kagan for beauty and compassion—it is to her that this text is affectionately dedicated. This study of Chagall's work is greatly indebted to Franz Meyer's comprehensive monograph on Chagall published in 1964; the reader in need of additional information should seek it there. Useful biographical information can also be found in Jean-Paul Crespelle's *Chagall* (1970) and in the catalog of the Chagall exhibition held at the Philadelphia Museum of Art in 1985, edited by Susan Compton.

Series design by Howard Morris
Designer: Publishing Synthesis, Ltd., New York
Editor: Nancy Grubb
Picture editor: Massoumeh Farman Farmaian
Production manager: Dana Cole
Exhibitions, Public Collections, and Selected Bibliography compiled by Amy Handy

FRONT COVER: *Paris through the Window*, 1913. Oil on canvas, 53½ × 55¾ in. Solomon R. Guggenheim Museum, New York.
BACK COVER: *Dedicated to My Fiancée*, 1911. Oil on canvas, 77⅛ × 45 in. Musée des Beaux-Arts, Bern.
END PAPERS: Chagall in his studio. Photographs by Alexander Liberman.
FRONTISPIECE: *The Green Violinist*, 1923–24. Oil on canvas, 78 × 42¾ in. Solomon R. Guggenheim Museum, New York.

Marginal numbers in the text refer to works illustrated in this volume.

Library of Congress Cataloging-in-Publication Data
Kagan, Andrew.
 Marc Chagall.

 (Modern masters series; ISSN 0738-0429; v. 13)
 Includes index.
 Bibliography: p.
 1. Chagall, Marc, 1887–1985. 2. Artist—Russian S.F.S.R.—Biography.
I. Title. II. Series: Modern masters series; v. 13.
N69999.046K34 1989 709.2 89-6693
ISBN 0-89659-932-9
ISBN 0-89659-935-3 (pbk.)

First edition

Contents

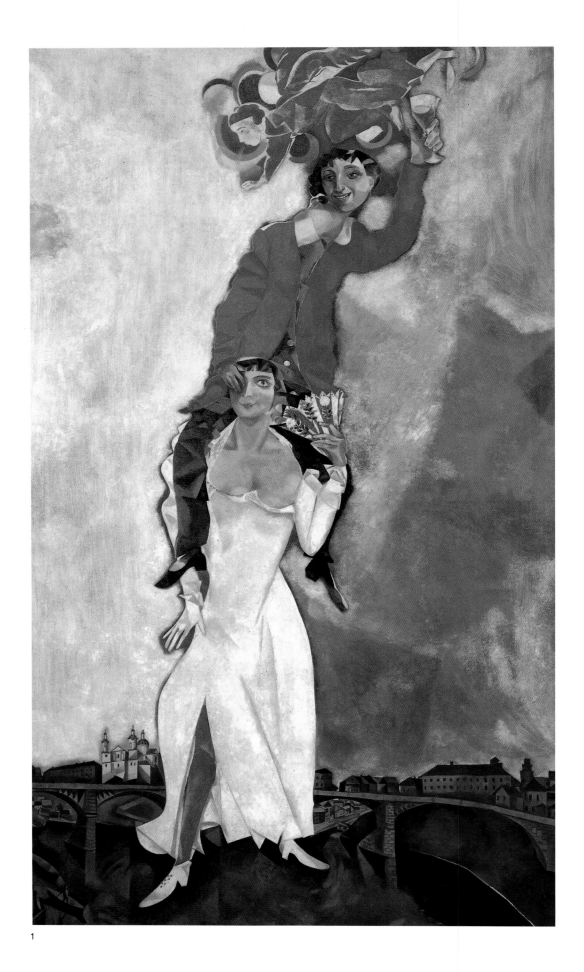

Introduction

Marc Chagall was the poet of twentieth-century art. In an age that placed primary emphasis on the "music" of visual art—the content arising from the interaction of its formal elements—Chagall appears to have clung to the ancient doctrine of *ut pictura poesis*. This doctrine, essentially an extended analogy between painting and poetry, held that a painting, like a poem, ought to symbolize the experiences of life and the feelings they evoke. Chagall had dreamed of being a poet in his youth and remained a lover of poetry throughout his life. In his autobiography, *My Life* (1922), itself a lyric prose poem, he spoke of his boyhood attempts at verse:

Night and day I wrote verses. People spoke well of them. I thought: I'll be a poet. . . .
 As soon as I learned how to express myself in Russian, I began to write poetry. As naturally as breathing.[1]

He began to write poetry again in the 1930s and continued to do so until the end of his life.[2]

For the poet Chagall, the essential functions of a painting were symbolic, not formal. To be sure, he subscribed to the twentieth-century doctrine that a work of art, which is constructed of basic forms and colors, must succeed first of all in visual terms. And indeed, Chagall was a brilliant colorist, one of the greatest of this century. But what matters finally in his art is the very personal sensibility communicated, as in poetry, through the arrangement of his particular forms and symbols. For Chagall the work of art was more than anything else a means to record his sensations, his memories, his moods, his feelings about his life. Late in life he said, "Some have blamed me for putting poetry into my paintings. It is true that one should expect other things from pictorial art. But let someone show me one single great work that doesn't have its share of poetry!"[3]

Chagall's art is a lyric of love—love of his native village and his childhood, his parents, his two wives, love of nature and of life itself. "Is it not true that painting and color are inspired by

1. *Double Portrait with Wineglass,* 1917
Oil on canvas, 91¾ × 53½ in.
Musée National d'Art Moderne,
Centre Georges Pompidou, Paris

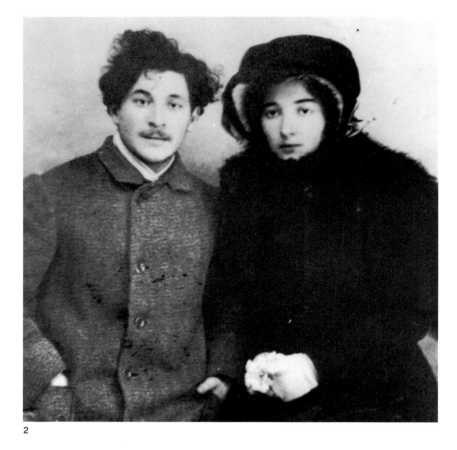

2

love?" he wrote in 1973, at the age of eighty-five. "It is our duty to color our own lives with shades of love and hope. . . . In art, as in life, all is possible when conceived in love."[4] He spoke also of "that all-encompassing affection I have, in general, for all mankind."[5] The objects of Chagall's affection and fantasies—the goats, chickens, and cows, the fiddlers on the rooftops of his native village, his mother's shop, his relatives and neighbors (all lovingly recalled in *My Life*)—reappear throughout his work, from his earliest efforts to those of his last years. Figures of tenderly entwined lovers enveloped in bouquets are another constant; Chagall was still painting these passionate lovers in his late nineties, just prior to his death in 1985.

Although Chagall suffered moments of melancholy, bereavement, disappointment, displeasure, and anger, even hunger, poverty, and the threat of persecution, his art only rarely speaks of such experiences. The sustained hostilities, the despair, the depressions to which so many famous artists have been prey were unknown to him. A muted "poetry of tragedy" occasionally finds its way into his work, but it does not prevail. He was not without cynicism, nor without antagonism toward his critics and detractors; and he would, at times, vent an acidic sarcasm against artists he disliked. But these occasional negatives notwithstanding, Chagall's spirit was devoted to rejoicing in life. His belief in himself was unshakable. He passed through his trials with the blithe composure of a sleepwalker, oblivious to perils narrowly avoided. Whenever Chagall found himself in a crisis, there was always a

2. Chagall and his fiancée, Bella Rosenfeld, c. 1910

3. Chagall and his wife, Valentine (Vava) Chagall, Saint-Paul-de-Vence, France, c. 1952

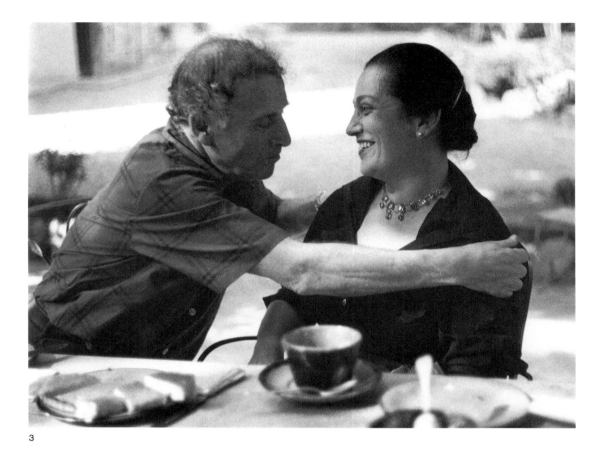

3

guardian angel to rescue him (these angels, too, find a place in his iconography). In 1922, at the age of thirty-five, he declared, "All days are fine!"[6] In his eighties he wrote, "The end of life is a bouquet."[7]

Given the personal, often pastoral, character of Chagall's work, it is surprising to learn just how deeply he was involved in the life and politics of his times. From the bohemia of Paris in the last years of the Belle Epoque he returned to his native Russia, eventually becoming an academician and an art commissar, enmeshed in the politics of the Russian Revolution. Although he was an irrepressible optimist, Chagall was by no means oblivious or insensitive to the troubles of humanity. Yet he was never distressed by these matters to the point of despair. He was blessed with limitless energy and self-confidence, with the resilience to survive trials, and with a readiness to find fulfillment in his work and in his love of those near to him.

The fruit of Chagall's long life was a vast body of work in many different media—paintings; graphic works (lithographs, etchings, poster prints) beyond number; book illustrations; set designs for theater and ballet; ceramics and sculpture in bronze, stone, and marble; mosaics and tapestry designs; and, in the large-scale public commissions of his later years, murals, ceilings, and stained-glass windows. The finest examples of this prodigious output placed Chagall among the masters of twentieth-century art. But even in the least of his creations he managed to share some of his extraordinary joy and faith with the many lovers of his art.

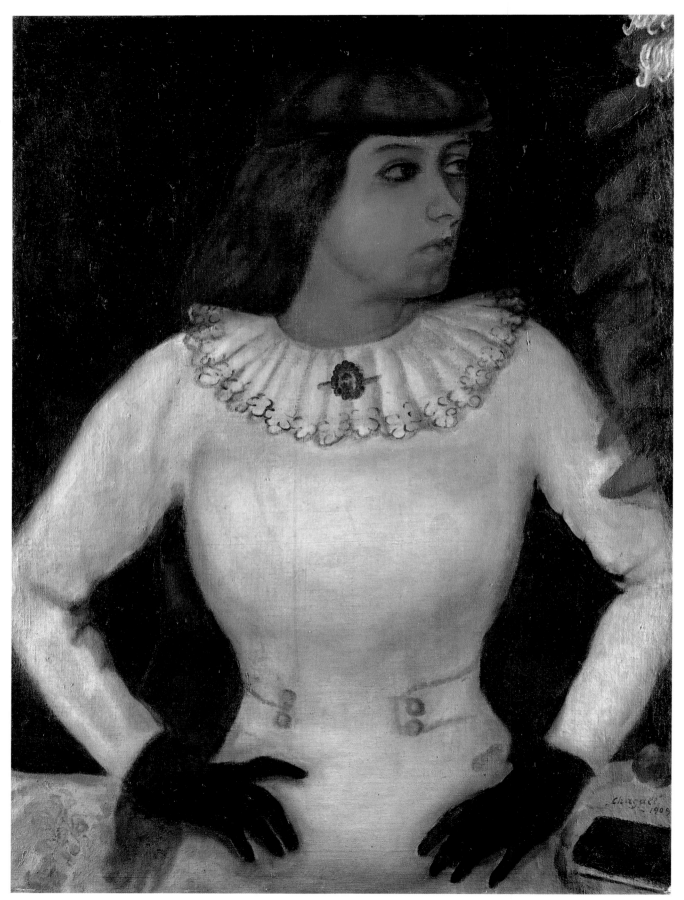

4

1 Vitebsk

Marc Chagall was born in Vitebsk on July 7, 1887. He was the first of the nine children of Zahar and Feiga-Ita Chagal. Zahar, a tall, shy, reserved man, worked for a herring merchant as a packer, hauler, and sometime clerk. Feiga-Ita, more energetic and ambitious than her husband, ran a small grocery shop and managed a few rental properties. The family name was originally Segal, a common name in that area, but Zahar had changed it to Chagal. His eldest son later changed the name to the more French-sounding Chagall, adding a second *l* and shifting the emphasis to the second syllable.[8]

Vitebsk, located in northwestern Russia (Caucasian or White Russia), was then within the so-called Pale of Jewish Settlement. Jews were permitted to live freely in the towns there, as they were not in, for example, Moscow and Saint Petersburg. At the time of Chagall's birth, the Jewish population of Vitebsk constituted about half of the total census of approximately fifty thousand. A thriving port, Vitebsk had rail facilities, a growing industrial base, and some impressive cathedrals and commercial structures. But it was, on the whole, a provincial town. The majority of its dwellings were rude timber structures. The goats, chickens, and cows that would later fill Chagall's paintings roamed through backyards and along the unpaved streets. Chagall affectionately recalled that his relatives and neighbors would climb the pitched roofs of the low houses to view events in the town or simply to gaze at the heavens. Those figures on rooftops were to play a prominent role in his art.

Like most Jews in the Caucasus, the Chagalls were Hasidim. That is, they were affiliated with the Jewish revivalist movement founded in the eighteenth century by the rabbi-mystic Israel ben Eliezer, known to his followers as the Ba'al Shem-Tov (Master of the Good Name). The essence of Hasidic thought is that fervor and joy are as important in the effort to attain communion with God as study of the law of Moses. Thus there is a strongly anti-rationalist current in the Hasidic faith, somewhat in contradiction to the strict, legalistic tradition of Talmudic scholarship. The floating, dreamy visions of Chagall's art have a background in Hasidic spirit, myth, and lore.

4. *My Fiancée in Black Gloves,* 1909
Oil on canvas, 34⅝ × 25⅝ in.
Offentliche Kunstsammlung, Kunstmuseum
Basel, Basel, Switzerland

Although the Chagall family devoutly observed Jewish ritual, there was already among them, as among the town's Jewish population in general, some opening to elements of Russian and Western European culture. Thus while the family conversed in Yiddish at home, the children spoke Russian with their friends on the street. The young Chagall would even wander into churches to gaze at the icons and stained glass. He received his elementary education at the *cheder,* the Jewish lower school. But after he had been there for seven or eight years, his mother took advantage of an opportunity to enroll him in the public upper school, where lessons were taught in Russian.

A dreamy child, Chagall was not a good student, although he excelled in geometry and drawing. He had taken violin and singing lessons but was really attracted only to drawing, and the vague notion of becoming an artist began to occur to him. There was little in his background to have dictated this choice of career, although he later recalled his childish excitement over the illustrations ("the lines, the pictures") in the *Haggadah,* the ritual prayer book used at the Passover festival.[9] Above all, he said, he felt compelled to avoid the drabness and drudgery of his father's life. Although Chagall's childhood was an extremely happy one, one of his strongest impressions was that of his father's melancholy and exhaustion. Even as a youth, Chagall knew that he needed to find a more colorful path in life.

Upon completing his six years at the public school, Chagall persuaded his mother to let him enroll at the studio-academy of Jehuda Pen, the most eminent Jewish painter in Vitebsk. Feiga-Ita was not at all sure about this decision and at first suggested that her son consider becoming a clerk. For the child of a humble and devout Jewish family to become an artist was by no means a commonplace matter. Not only is there a strong anti-iconic tradition in Judaism, but few careers seem less practical than that of a painter. But Chagall, the first born, was his mother's darling, and she could not deny his desire. Her strong will and her son's budding talent prevailed in winning over her husband and other relatives.

Chagall was about nineteen when he began his brief period of study with Pen in 1906. Jehuda Pen had studied at the Saint Petersburg Academy and had established himself in Vitebsk as a painter of genre scenes and portraits in an academic manner. Although Chagall recalled his first teacher with great affection, he also recalled that, upon his entry into Pen's studio and his first encounter with this local master's works, he had "already decided that I'll never paint like that."[10] Chagall knew that, for himself, "the essential thing is art, painting, a painting different from the painting everyone else does."[11] He soon became notable among Pen's students as "the only one who painted with violet."[12]

Among the works Chagall produced during this period is a watercolor entitled *The Musicians,* which shows the artist moving toward a personal, even expressionist approach.[13] There is no attempt at convincing perspective or photographic depiction. The treatment of light, space, and anatomy is very free, improvisatory, with a deliberately crude, primitive quality that suggests Chagall's

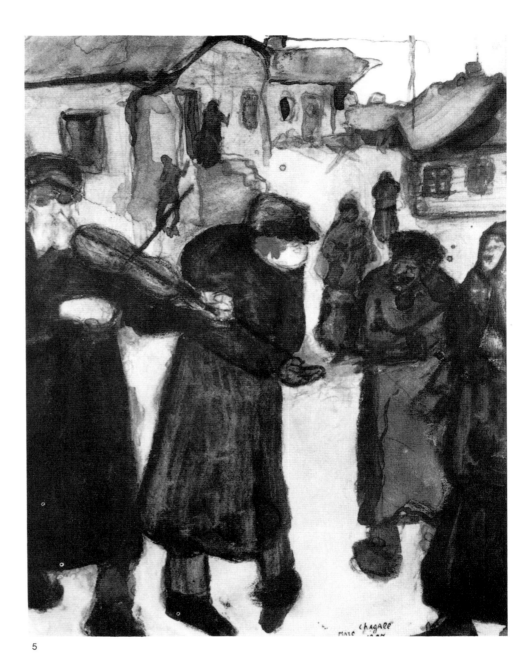

5

early quest for a poetic voice of his own, in opposition to the traditional representational studies prescribed by his teacher.

One of the most important events of Chagall's stay at Pen's was his meeting Victor Mekler, a fellow pupil who became his friend. Mekler was the son of a wealthy merchant, and through him Chagall entered a more enlightened and prosperous circle in Vitebsk. Membership in this circle contributed to Chagall's sense of importance and self-confidence as well as to his awareness of current developments in art. In the winter of 1906–7 Mekler persuaded Chagall to give up study at Pen's, to leave Vitebsk, and to explore the larger art world of Saint Petersburg. Although Chagall was eager for this new experience, he probably needed the greater worldliness and the daring of his new friend to help him make the break.

5. *The Musicians*, 1907
Watercolor on paper, 11⅛ × 8⅞ in.
Estate of the artist

Chagall's poverty made the move a series of difficult adventures. While at Pen's he had briefly worked as a photographer's re-toucher, a job he detested for its acts of falsification. But upon his arrival in Saint Petersburg he was forced once more to resort to this occupation, taking employment with a photographer to whom he had been recommended by Pen. At first Chagall could afford only the most miserable accommodations, being obliged to share rooms and even beds with a variety of equally destitute characters. He even was imprisoned for two weeks, following a visit to Vitebsk, when he tried to re-enter Saint Petersburg without the special pass required of Jews. He then attempted to become a sign painter, in order to learn a trade that would insure him a residence permit, but he failed the examination. Chagall recounted these trials with humor and no sense of bitterness. Eventually he was rescued from the worst of his financial distress by a series of wealthy Jewish patrons—among them Baron David Ginsburg and Max Vinaver, an enlightened politician and influential member of a circle of Jewish liberals who sought to promote a renaissance of Jewish culture.

In April 1907 Chagall's talents were given some recognition when the Imperial Society for the Protection of the Arts granted him a fee remittance at the Saint Petersburg Academy. In September he received a one-year scholarship. Never one for academic routine, Chagall did not complete that year, leaving the Academy in July 1908. Far more important than what he had learned there was the art he saw at the homes of his patrons and their friends. At this time in Saint Petersburg there were impressive private collections of avant-garde paintings from Paris. What clearly made the greatest impression on Chagall were the works by Paul Gauguin and Vincent van Gogh.

Gauguin exerted a profound and enduring influence on the young artist. Chagall later called this master "the only revolutionary," and in 1956 he painted *Homage to Gauguin* (based on Gauguin's *Te Rerioa*), the only explicit homage to another painter in Chagall's entire oeuvre.[14] Gauguin must have provided Chagall with a signpost toward a new freedom of personal expression. Chagall no doubt also responded strongly to Gauguin's ability to endow commonplace forms with a mystical aura. Equally important was Gauguin's authoritative insistence that a revitalization of Western high art demanded recourse to other, far different cultures and traditions.

In Chagall's *Young Girl on a Sofa*, a portrait of his sister Mariaska made on one of his frequent visits to Vitebsk, the influence of Gauguin's Tahitian period is unmistakable. The figure of the seated young girl is tailored to the frame of the picture. The arrangement of her crossed legs suggests the pose in several of Gauguin's paintings of Tahitian women. Using the design of the upholstery fabric to help set up a rhythmic surface pattern, Chagall flattened and compressed all the forms into the foreground. He thereby created the type of flat surface design that Gauguin and many of his contemporaries had taken as their main point of inspiration from Japanese prints. Also from Gauguin is the rich, bright, tropical color and the sense of mystery surrounding the

6. Paul Gauguin (1848–1903)
Self-Portrait, 1889
Oil on panel, 31¼ × 20¼ in.
National Gallery of Art, Washington, D.C.;
Chester Dale Collection

7. *Self-Portrait,* 1908
Oil on canvas, 11¾ × 9½ in.
Musée National d'Art Moderne,
Centre Georges Pompidou, Paris

8. *Young Girl on a Sofa (Mariaska),* 1907
Oil on canvas, 29½ × 36½ in.

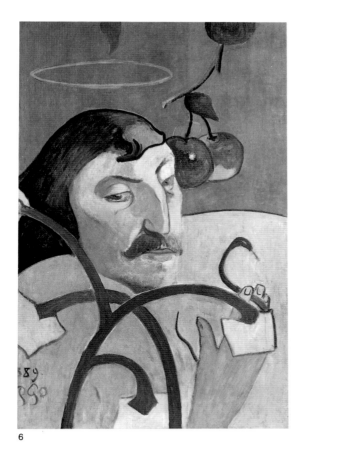

6

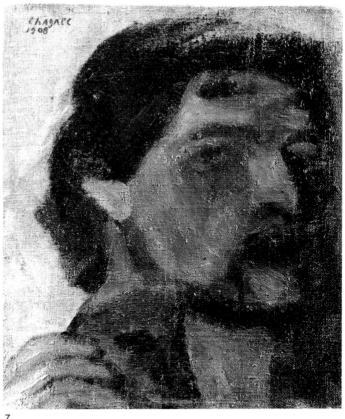

7

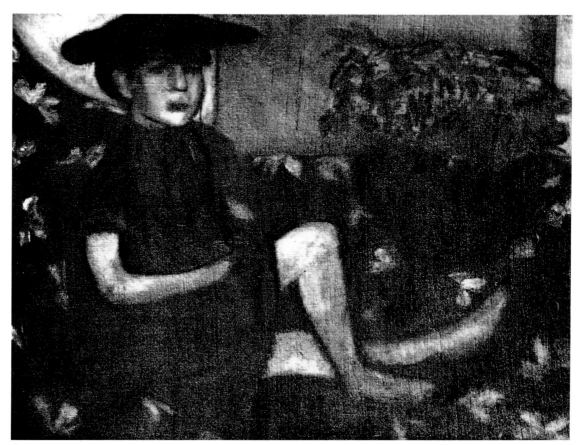

8

7 figure. In a self-portrait dated 1908 Chagall appears to have identified himself with Gauguin almost literally, so strongly does this
6 work echo Gauguin's haunting self-portraits of about 1890, with Chagall's stern visage portrayed in three-quarter view, the drooping mustache accentuating the down-turned mouth. There is a distinct suggestion that this is a mystic, a saint, or a visionary.

Chagall's awareness of van Gogh is revealed in an important
9 painting of 1908 entitled *The Dead Man,* arguably the most important single painting of his student years. Here, perhaps for the first time, Chagall had reached deep within his own experience to attempt an image charged with emotion. Technically and structurally, this work depends on townscapes by van Gogh, with their irregularly distorted perspective, their flattened figures in deep, open space, and their broad, empty skies. The unnatural greenish yellow of Chagall's sky and the contrasts of the greens and the earth tones also seem to derive from van Gogh. But for the subject, Chagall drew upon a moving experience from his own childhood, as recounted in his autobiography: "Suddenly one morning, well before dawn, shouts rose from the street below our windows. By the faint light from the night lamp, I managed to make out a woman, alone, running through the deserted streets. She is waving her arms, sobbing, imploring the inhabitants, still asleep, to come and save her husband." Later, he recalls, "the light from the yellow candles, the color of that face, barely dead . . . convince me . . . that it's all over. . . . The dead man, solemnly sad, is already laid out on the floor, his face illuminated by six candles."[15]

Chagall also notes that this painting was most directly inspired by a recent view of a deserted street that had struck him with a strange feeling of desolation and impending tragedy. "How," he asked himself, "could I paint a street, with psychic forms but without literature? How could I compose a street as black as a corpse but without symbolism?"[16] His answer appears to have been that he could not and that he was forced to use the symbols of memory as well as the techniques of van Gogh to realize his goal. Chagall's evocative fiddler on the roof (who, half a century later, was to become a folk hero of stage and screen) appears here for perhaps the first time, as a poignant counterpoint to the dead man. The composition is among the most complex of Chagall's early efforts, with the order and repose of the forms on the left offset by the agitation of those on the right, and with the diagonal thrust of the woman helping to reinforce the mood of pathos and intense emotion.[17] He was assisted here too by van Gogh's highly expressionistic concepts of light and dark, so conditioned by traditional Dutch painting. In contrast to Gauguin, whose paintings, like Japanese prints, generally seem to have no specific source of illumination, van Gogh was almost obsessed with natural and manmade light—sun, moon, stars, lamps, and candles.

Late in 1908 Chagall enrolled at the Svanseva School, which one of his patrons had recommended because of the teaching of Léon Bakst. Bakst was soon to become internationally famous as the costume and set designer of Sergei Diaghilev's Ballets Russes in Paris. In Saint Petersburg he was already making a name for himself as a flamboyant exponent of Art Nouveau modernism.

9. *The Dead Man,* 1908
Oil on canvas, 27⅛ × 34¼ in.
Musée National d'Art Moderne,
Centre Georges Pompidou, Paris

10. *Birth,* 1910
Oil on canvas, 25⅝ × 35¼ in.
Kunsthaus, Zurich

9

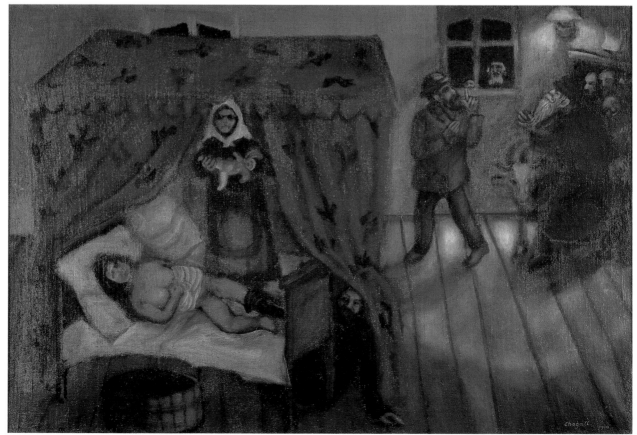

Predictably, Chagall learned almost nothing in the way of style or technique at the Svanseva School, but he was greatly encouraged by Bakst in the exploration of modernism and in looking toward Paris as its primary source. As his rather dandified 1909 self-portrait makes clear, Chagall was also acquiring a little flamboyance of his own, depicting himself in the manner of self-portraits by Rembrandt or the Italian Mannerist Bronzino.

During this year Chagall frequently interrupted his work in Saint Petersburg to return to Vitebsk. Through his friend Victor Mekler he had met Thea Brachman, the daughter of a prosperous physician. She was an educated, intelligent, artistic, and liberated young woman with whom he shared rich conversation and pleasurable companionship. But in the autumn of 1909 Chagall met Thea's friend Bella Rosenfeld, and his life was instantly transformed: "Her silence is mine. Her eyes, mine. I feel she has known me always, my childhood, my present life, my future; as if she were watching over me, divining my innermost being, though this is the first time I have seen her. I know this is she, my wife. Her pale coloring, her eyes. How big and round and black they are. They are my eyes, my soul. I knew that Thea was nothing to me, a stranger. I have entered a new house and cannot be parted from it."[18]

This was the beginning of a remarkable romance that was to endure for over thirty-five years. One of Chagall's earliest portraits of Bella, *My Fiancée in Black Gloves*, is also one of the best known. Bella, the daughter of a very wealthy jeweler in Vitebsk, had attended an exclusive private girls' school in Moscow, where she had taken Konstantin Stanislavsky's courses in theatrical arts. Here, in her slightly theatrical pose, Chagall portrays the spirit of this woman as he would always see her—passionate, defiant, intense.

Through 1909 and 1910 Chagall spent about half his time in Vitebsk and half in Saint Petersburg, where he continued to attend Bakst's courses. During this period he experimented with a range of styles, including caricatures and satiric, cartoonlike drawings. After his first encounter with Bella, Chagall's art underwent a significant change. With growing confidence and determination he began to develop a new, personal approach based on his own heritage and background. The initial result was a series dealing with aspects of Jewish ritual and family life, no doubt sanctioned in part for him by Gauguin's recourse to "exotic" cultures.

In *Circumcision* the stylistic debt, as well as the spiritual debt, is again to Gauguin, in the linear surface patterns and flattened figures compressed into the foreground. We are shown the *mohel* (the Jewish ritual circumciser), the infant boy, and the grandparents enacting the *bris* (the covenant of Moses), a central ceremony of the Jewish religion. In the ink drawing *Ritual Bath*, Chagall depicted in a cartoonlike style the *mikveh*, the communal bath of purification attended monthly by orthodox Jewish women. In *Birth* he presented a rather somber scene of pain and joy, illumined by a lamplight recalling that in van Gogh's early *Potato Eaters*. Here, as in *My Fiancée in Black Gloves*, already appears

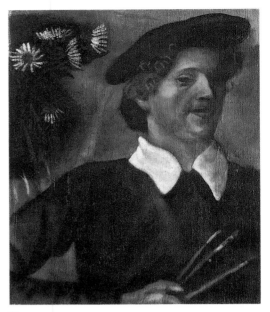

11

12

13

the undulating, softly rhythmic color chiaroscuro that was to become so characteristic of Chagall's mature painting style.

In the spring of 1910 Bakst left Saint Petersburg for Paris, to take the position in Diaghilev's ballet company that was to bring him fame. Chagall, with his art rapidly approaching a first maturation, also felt the need to visit the capital of art, and he asked his mentor for a job as an assistant stage decorator. Bakst, finding Chagall "clumsy" as a set decorator and knowing that his student was too independent of spirit ever to be a mere assistant, turned him down. Fortunately, Chagall's patron Vinaver again came to the rescue. In exchange for a single painting and a single drawing, he offered Chagall a stipend that would enable him to spend almost four years in Paris. In August 1910 Chagall packed up all of his works and supplies, boarded a train, and left Russia for the first time.

11. *Self-Portrait with Brushes,* 1909
Oil on canvas, 22½ × 18⅞ in.
Kunstsammlung Nordrhein-Westfalen,
Düsseldorf, West Germany

12. *Circumcision,* 1909
Oil on canvas, 29⅛ × 26⅜ in.

13. *Ritual Bath,* 1910
Pen and ink on paper, 8⅝ × 9 in.
Israel Museum, Jerusalem; Gift of Mr. and
Mrs. Daniel Saidenberg, New York, to the
American-Israel Cultural Foundation

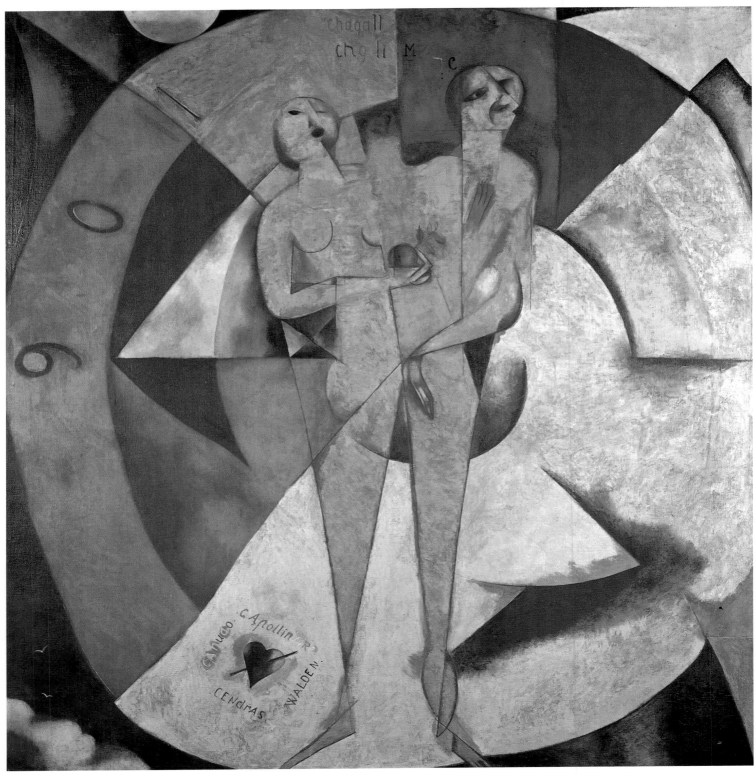

14

2 Paris

At the end of a four-day journey Chagall arrived in Paris. He later described himself as "one driven on by Fate. . . . full of eagerness to shine with this light of Paris."[19] Here he could breathe "the air of freedom," living in a place where art was as important as, if not more important than, anything else—where living for art was accepted and even admired, as it was not in Saint Petersburg and certainly not in Vitebsk. It was here, in the years before World War I, that he first developed the style we know as Chagall's.

Chagall was greeted at the station by his friend Victor Mekler, in whose hotel room he stayed for a few days. Mekler had come to Paris the previous year to study art, or at least to live for a while the life of an art student. (He returned to Russia a year later.) Homesickness and a sense of being in an alien environment temporarily afflicted Chagall, but he soon met other Russian artists and critics who helped him through these initial difficulties. One of his compatriots sublet him a two-room studio in Montparnasse, the district that became renowned as an artists' quarter, and there Chagall began to work. He attended two art schools in Montparnasse, La Grande Chaumière and the Palette, where the minor Cubists Henri Le Fauconnier and André Dunoyer de Segonzac taught. Chagall learned little of immediate value in these academies; his true schools were the Louvre, the Salons, and the galleries. All around him were the finest canvases by van Gogh, Gauguin, and the Impressionists, whose work he already knew, and by Paul Cézanne, Henri Matisse, and the Fauves, who were newer to him. The work of these more recent masters he termed a "revolution of the eye."[20] Their innovations in the use of subjective color and form gave him the keys to liberate his own highly original sensibilities.

One of the first paintings Chagall executed in Paris was *The Sabbath,* a continuation of the Jewish ritual series he had begun in Russia. The figures are detached and remote, in the sleepy, dreamlike atmosphere of a Sabbath evening. Like its predecessors in the series, the painting derives in form and color principally from van Gogh. The faces, though, recall not that artist but the otherworldly visages found in Byzantine and Russian icons. This tradition, so fundamental to Russian culture, was familiar to Cha-

14. *Homage to Apollinaire,* c.1912–13
Oil on canvas, 78 × 74¼ in.
Stedelijk van Abbemuseum, Eindhoven,
The Netherlands

15

gall from his days in Saint Petersburg, and it remained an important source for his art.[21]

Through 1910 and early 1911 Chagall's efforts continued to
16 depend on formal elements found in the art of van Gogh. *The Harvest* recalls several sunlit depictions by van Gogh of a lone peasant working in the fields, although the color seems influenced by Chagall's exposure to paintings by Henri Matisse, Pierre Bon-
17 nard, and perhaps André Derain. The *Village Store* harkens back
9 to the van Gogh–like composition of *The Dead Man*. The sign on the store—a sign appearing repeatedly in Chagall's work— recalls the one on his mother's store in Vitebsk. A new element is the appearance, on the left side of the painting, of detached brush-

15. *The Sabbath,* 1910
Oil on canvas, 35⅜ × 37⅜ in.
Museum Ludwig, Cologne, West Germany

strokes that create a sense of the surface plane of the picture and of space opening behind that plane. This technique derives, of course, from Impressionist and Postimpressionist painting, but it commonly appears also in the art of children. In *The Studio*, a rendering of Chagall's room in Montparnasse, there remains some suggestion of van Gogh's interior scenes, but the forms, colors, and spaces have become more freely distorted, more "subjective," in the manner of Fauvist and Expressionist painting.

The year 1911 was one of striving and exploration for Chagall, a year also for assimilating crucial new sources. But it was not an especially successful year for his career. He attempted to exhibit his work at the Paris Salon d'Automne, but it was rejected. He submitted several paintings for an exhibition in Saint Petersburg, but only one, *The Dead Man,* was accepted. Still, there were encouraging moments. In June 1911 Chagall's former teacher Bakst visited him and praised his work, declaring "now your colors sing."[22] This favorable comment from a noted colorist helped to sustain Chagall's morale, for he was already conscious of the central role that color was going to play in his art. The most important occurrence of 1911 was Chagall's opportunity that spring to view, at the Salon des Indépendants, the work of Robert Delaunay and Fernand Léger. These artists had come under the sway of the Cubism recently invented by Pablo Picasso and Georges Braque, but they rejected its sculptural gray and brown monochromy. The two younger men sought instead to synthesize the rich color of their own earlier Fauvist works with the structural innovations of Cubism. This merging of intense color with the most radical Cubist innovations in pictorial structure was a revelation for Chagall, and the influence of this new coloristic Cubism began to appear in his art during that year. In *Still Life,* for example, instead of trying to construct a spatial composition with traditional perspective, Chagall attempted for the first time to geometricize the background space in order to integrate it with the picture plane and with the represented objects in a coherent, unified pattern.

At the beginning of 1912 Chagall made a fateful move. Leaving his rooms in Montparnasse, he relocated to outlying Vaugirard. It was a district of slaughterhouses and meat packers, an environment not at all alien to Chagall, who as a boy had spent summers visiting his maternal grandfather, a butcher in the town of Lyozno. In Vaugirard he took up lodging in a curious habitation known as La Ruche (The Beehive). This dodecagonal structure had served as the rotunda of the wine pavilion at the 1900 world's fair. An enterprising sculptor had purchased it, relocated it, and transformed it into studios for artists of humble means. Twelve studios were arranged on two floors around a central staircase. Living conditions were primitive, but circulating through this ramshackle structure were numerous figures on the threshold of fame—Léger, Amedeo Modigliani, Chaim Soutine, Ossip Zadkine, and Chagall, among others. La Ruche was to become as legendary a landmark in the second decade of the twentieth century as the Bateau Lavoir, occupied by Picasso and Braque, had been in its first.

It was here that Chagall met the poets and critics who were to be so crucial to his emergence from obscurity. Among these lit-

16

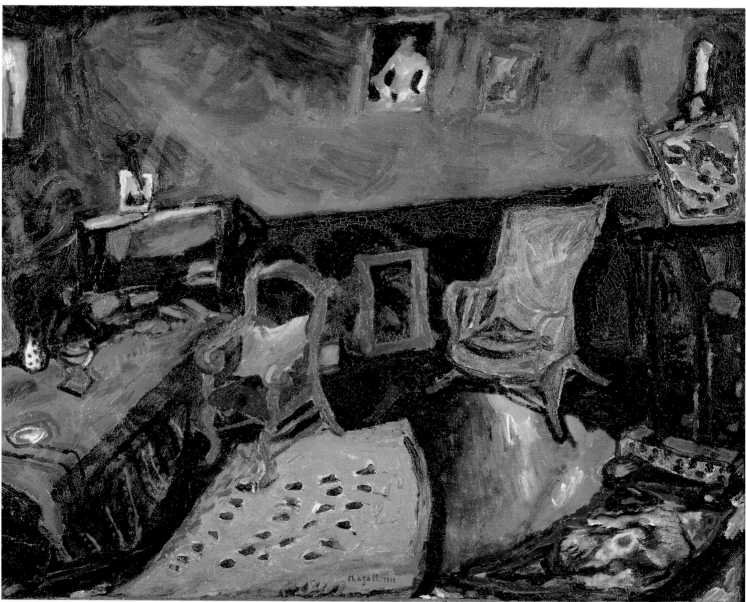

18

16. *The Harvest,* 1910
Oil on canvas, 23⅝ × 31⅞ in.
Musée National d'Art Moderne,
Centre Georges Pompidou, Paris

17. *The Village Store,* 1911
Gouache on paper, 7⅝ × 8⅝ in.
Private collection

18. *The Studio,* 1910
Oil on canvas, 23⅝ × 28¾ in.
Musée National d'Art Moderne,
Centre Georges Pompidou, Paris

erary figures were Blaise Cendrars, Riciotto Canudo, Guillaume Apollinaire, and the Marxist Anatoly Lunacharsky. These writers were powerfully and immediately drawn to Chagall's highly poetic images, whether they understood them or not. Cendrars, for example, included passages on Chagall in several of his poems from this era. These writers provided Chagall with the public exposure, the contacts, the moral support, and not least, the exchange of ideas and information he needed to develop, in the next two years, into an important member of the Paris art world.

Perhaps the most significant idea that Chagall acquired in this milieu was the concept of simultaneity, which absorbed both Cendrars and Apollinaire. Simultaneity, as an aesthetic concept, derived originally and principally from M. E. Chevreul's treatise *The Law of Simultaneous Contrast of Colors* (1839), a work that influenced many nineteenth-century French painters, most notably Georges Seurat and the Neo-Impressionists. By 1912–13 Delaunay, Apollinaire, and the other artists and writers in their circle had turned the idea of simultaneity into something of a movement, affecting all the arts. Apollinaire gave to this movement the name Orphism. It is important to note that in prewar Paris "simultaneity" was not merely an arcane password among intellectuals—it had become, in fact, a vogue, a banner for modernism in art and even in clothing, furniture, and automobiles.[23]

As interpreted by Cubists such as Picasso and Braque, simultaneity referred to the depiction of objects or figures as seen from several points at the same time. In Chagall's dazzling *Temptation (Adam and Eve)*, which was exhibited at the Salon des Indépendants of 1913, he experimented with the Cubist idea of geometricizing the human form into planes and synthesizing varied perspectives of those figures. But in this brilliant symphony of colors Chagall was far more concerned with hue and saturation than with form and line. In this delightful vision of paradise his colors truly "sing."

Robert Delaunay was only two years older than Chagall. Like Chagall, he was primarily a colorist and not oriented toward thinking in terms of solid objects and linear form. He was an intimate friend of Cendrars and Apollinaire, who not only communicated his ideas to Chagall but also arranged a meeting of the two artists. Chagall became a frequent guest at gatherings in the home of Delaunay and his wife, Sonia, herself a simultanist-colorist painter of note and a principal instigator of simultaneity in the world of fashion. Sonia also happened to be Russian, from the area of Saint Petersburg, and this may have helped facilitate communication between Chagall and her husband. Noted for his daring, Robert Delaunay boldly redefined all visual reality as the "rhythmic simultaneity" of light.[24] He first realized this radical idea in his Simultaneous Window series of 1912–13, a group of paintings that exerted an enormous influence on artists throughout the world. The fact that Delaunay's art also had a direct impact on Chagall is suggested by Chagall's *Paris through the Window*, a subtly humorous tribute to Delaunay.

Chagall's *Homage to Apollinaire* is another homage to Delaunay as well as to Apollinaire, whom Chagall first met when the

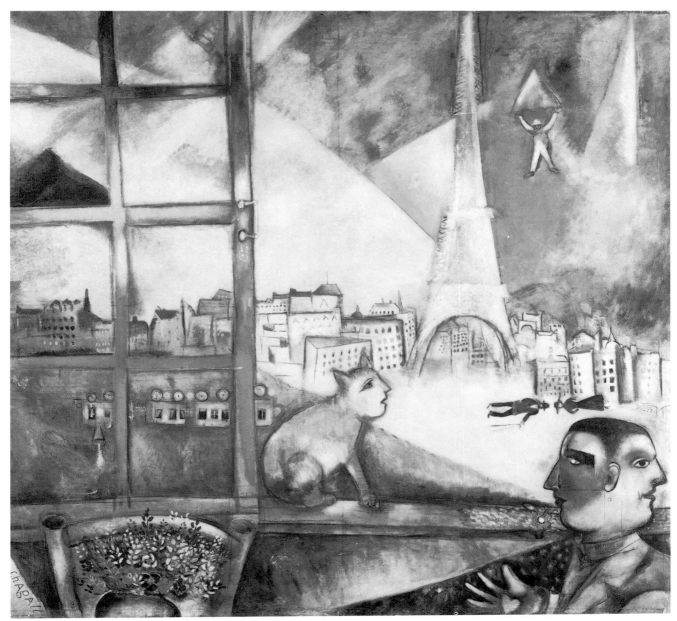

19

19. *Paris through the Window*, 1913
Oil on canvas, 53½ × 55¾ in.
Solomon R. Guggenheim Museum, New York

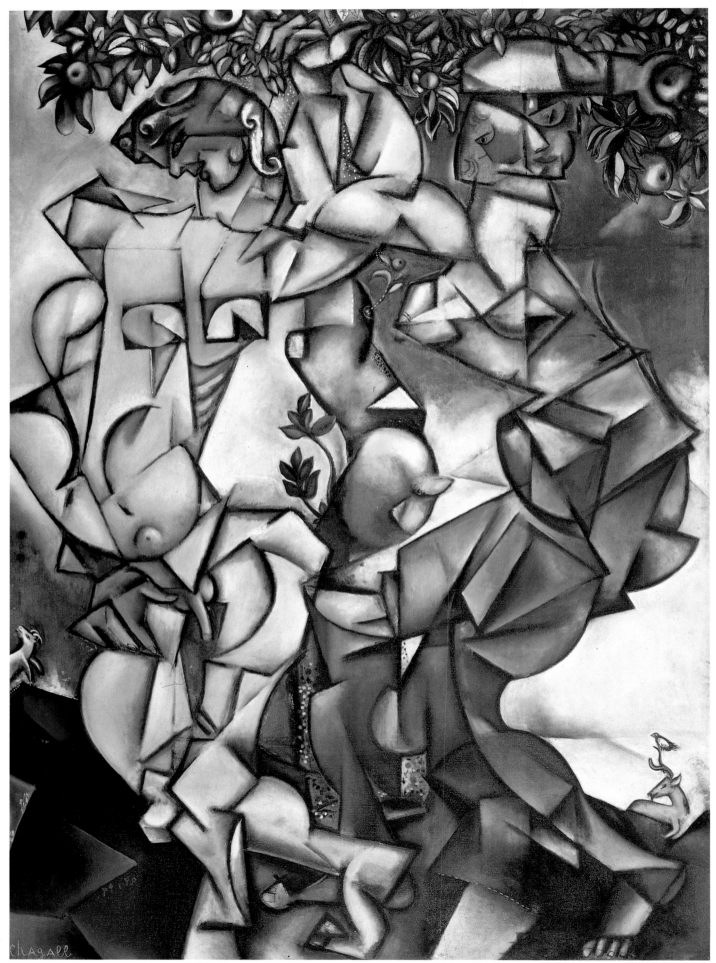

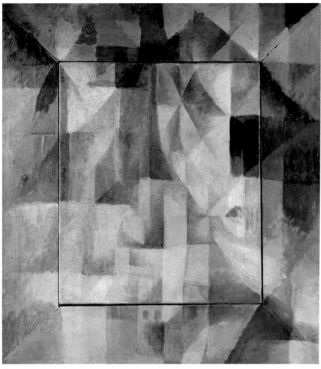

21

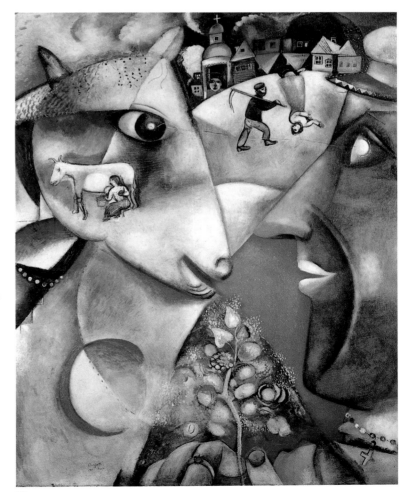

20. *Temptation (Adam and Eve)*, 1912
Oil on canvas, 63³⁄₁₆ × 44⁷⁄₈ in.
The Saint Louis Art Museum; Gift of
Morton D. May

21. Robert Delaunay (1885–1941)
Simultaneous Windows on the City, 1912
Oil on canvas, 18⅛ × 15¾ in.
Hamburger Kunsthalle, Hamburg,
West Germany

22. *I and the Village*, c.1912–13
Oil on canvas, 63⅝ × 59⅝ in.
Collection, The Museum of Modern Art,
New York; Mrs. Simon Guggenheim Fund

22

poet visited his studio in La Ruche early in 1913. In this work Chagall's Cubist Adam and Eve have been reunited and transformed within a new, painterly vision of paradise. At the lower left of this breakthrough painting Chagall inscribed his own name together with those of his literary "muses": Apollinaire, Cendrars, and Canudo, an influential critic who was also editor of an avant-garde periodical. Also named here is the noted Berlin picture dealer Herwarth Walden, who was to play an equally important role in Chagall's rise to fame. Although Delaunay is not mentioned by name, the clocklike color wheel that forms the background of this painting is unmistakably derived from Delaunay's revolutionary Circular Forms series—the proto-absolute paintings that he introduced in 1912–13.

The dual figure superimposed on the color wheel in *Homage to Apollinaire* evolved from a series of sketches titled *Adam and Eve*, which Chagall executed in 1911–12. These sketches have the character of medieval illustrations of the Old Testament. The figures are shown at the moment of Eve's creation, as she emerges from Adam's ribs. In this ancient exemplar of simultaneity, the two figures are still united, an image with strong overtones of the Hasidic idea of mystical union. The importance of this work for Chagall's development stems in large measure from the new treatment of space, for here the integration of figure, background, and picture plane is complete. There is no suggestion that these are actual figures situated in an actual world. The ability to conceive a work of art in this radical manner placed Chagall, at the relatively tender age of twenty-five, among the pioneers of twentieth-century art. Moreover, the colors in *Homage to Apollinaire* have already become Chagall's own, indebted to no one. These are rich, velvety colors, modulated in rhythms of light and dark, a hallmark of Chagall's mature painting style. The enigmatic, clocklike numerals introduce metaphorically the idea of time, perhaps an oblique reference to the concept of time as elaborated by Apollinaire, Henri Bergson, and other explicators of simultaneity.

It was not long after his *Homage to Apollinaire* that Chagall went on to interpret the concept of aesthetic simultaneity in his own highly original manner. And it was this interpretation as much as anything else that yielded his characteristic personal style. For Chagall, the simultaneity that came to matter most was not that of vision but of imagination and memory. And so he began to depict, in paintings ever less dependent on perception of the real world, the diverse images floating in his conscious and subconscious thoughts. In this dreamlike universe, all juxtapositions, all transformations, all apparitions were possible. The space of these paintings is neither the perspectival space of Chagall's early works, nor the Cubist space of Picasso, nor the Orphic space of Delaunay. It is, in effect, the space of Chagall's own dreams and imagination, and a decade later it would exert a seminal influence on the art of the Surrealists.

Among the earliest and most compelling of Chagall's works in his new style is *I and the Village* of 1911. This painting has the same sort of circular, faceted organization as *Homage to Apollinaire,* but here it creates an aura of magical revery. Dream images

22

and areas of pure color are layered in a dense, mysterious polyphony. Above floats the village of Vitebsk. At the left appears a diaphanous cow-goat, an image of rich associations for Chagall. At the right is a Russian peasant wearing a *moujik* cap and blouse and a cross with beads around his neck. (In spite of the title, this is not a self-portrait. The titles of this and several other paintings of the period were supplied by the poet Cendrars.) The arc of the peasant's green cheek accords neatly with the circular form dominating the center of the picture. In his fingers he holds a delicate branch displaying buds, berries, and snowflakelike blooms, which seems to vibrate with almost audible chimes.

Half-Past Three (The Poet), also titled by Cendrars, began as 23 a portrait study of a poet named Mazin, who also lived in La Ruche. But, as Franz Meyer observes, "Mazin is forgotten," and the figure assumes the dual character of the poet and of Chagall. The two figures are "representatives of different aspects of the same, artistic expression, which Chagall aspires to and realizes visually in painting, but which also embraces poetry. Thus, *The Poet,* though freed from all factuality, is no less Chagall himself— Chagall in search of the 'illogical, impossible aspect of our existence, the miracle, the other dimension.' "[25] Structurally, *The Poet* is conceived as a dramatic rush of flat, diagonal color planes, with wallpaperlike floral elements serving to compress the space, to establish the picture plane, and to add notes of whimsy. There is a suggestion of a late hour, the time Chagall favored for painting at La Ruche. The poet appears to be imbibing liquid inspiration from the bottle at right. His head, detached and inverted, recalls that of dreamers and drunkards from other Chagall works of this period. This poet appears to be writing from a palette of colors, an intriguing conceit that points up the common goals of the two arts (as conceived by Chagall) and echoes the experiments in "simultaneous" painting-poetry carried out jointly by Cendrars and Sonia Delaunay during this period, such as the "simultaneous book" entitled *La Prose du Transsibérien.*

In *Self-Portrait with Seven Fingers,* Chagall demonstrates ex- 93 plicitly the simultaneity of his visions. Over his shoulder at the upper left appears "Paris through the window," as denoted by the Hebrew characters spelling "Paris." Projected on the wall at the upper right is a scene from Vitebsk, enshrouded in the mists of memory and denoted by the Hebrew characters spelling "Russia." This is presumably what Chagall imagines as he works at the painting of a Vitebsk peasant and goat set upon his easel. The composition, with its elongated yellow floorboards, looks back in some respects to Chagall's earlier efforts based on interior scenes by van Gogh. However, the *Self-Portrait with Seven Fingers* is much flatter, with the faceted figure of the painter pushed almost entirely onto the foreground plane. His palette is a delectable and dazzling array of colors and forms. Why does the painter depict himself with seven fingers? That is one of Chagall's mysteries, the sort he could never really explain, any more than he could explain why his cows were green and floated through the air.[26]

Self-Portrait with Seven Fingers was exhibited at the Salon des Indépendants of 1914. In his review of that show Apollinaire

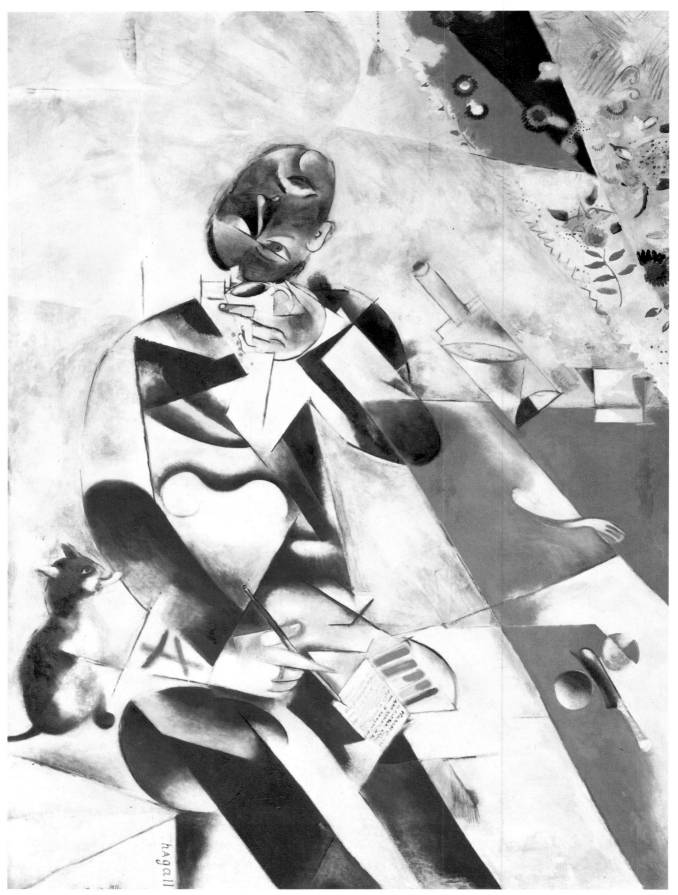

23

wrote, "Chagall is a gifted colorist who yields to every suggestion of his mystic, heathen fantasy."[27] Early in 1913 Apollinaire had arranged for the influential German dealer Herwarth Walden to visit Chagall's studio, and Walden was sufficiently impressed to include a few Chagall paintings in the Autumn Salon he held that year in his Sturm Gallery in Berlin. Recalling that visit, Walden's wife, Nell, later described Chagall as "a young man with curiously bright eyes and curly hair, who was idolized as an infant prodigy by his Parisian friends."[28] In 1914 Walden, with the assistance of Apollinaire, organized Chagall's first important one-man show, to run through June and July.

Having obtained a three-month visa from the Russian consulate in Paris, Chagall made plans to travel to Berlin for the opening of his show and then to take a brief trip to Russia, to attend his sister's wedding and to see Bella. At that moment he stood on the verge of international fame and celebrity, hailed as a major new force in modern art. But history, in the form of a world war, was about to intervene.

23. *Half-Past Three (The Poet),* c. 1912–13
Oil on canvas, 77½ × 57½ in.
Philadelphia Museum of Art; The Louise and
Walter Arensberg Collection

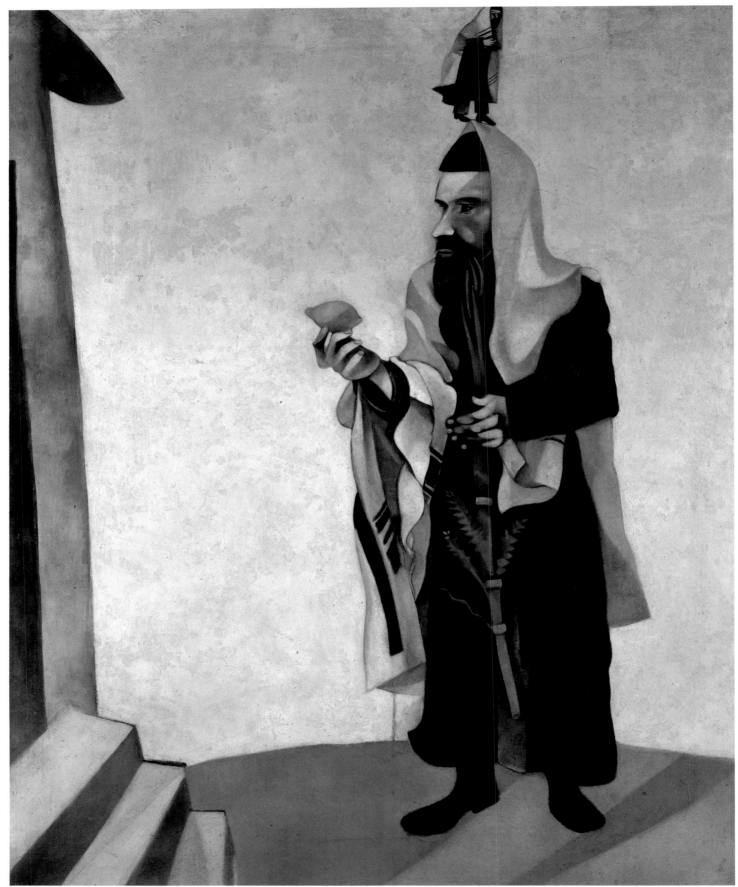

Return to Russia

On June 15 Chagall left Berlin on his journey home. Shortly after his arrival in Vitebsk, the European war erupted, and travel across borders was curtailed. It became impossible for Chagall to go back to Paris, and his three-month homecoming was transformed into an eight-year stay. One can well imagine that his confinement in his native town following the excitement, freedom, and celebrity of his years in Paris was not pleasant. And, indeed, Chagall referred to Vitebsk at this time as "a strange town, an unhappy town, a boring town."[29] His mood was reflected in small works such as *Clock,* a haunting image that shows the artist gazing wistfully out a window while the clock from his family's living room (a clock made in Paris) marks the slow passage of time.

The ever-resilient Chagall soon overcame his initial disappointment, and he began to rediscover and record his roots in Vitebsk in a series of fifty or so "documents." These works are fairly straightforward depictions of his family and scenes of village life, drawn on cardboard and paper. Among them are *Uncle's Store in Lyozno,* recalling the village where Chagall had spent summers during his boyhood, and *David in Profile (The Mandolin Player),* a portrait of his younger brother. This process of documentation began to merge with the advanced formal concepts of Chagall's last two years in Paris. The result was a series of images of elderly Jews, character types such as peddlers and beggars from his neighborhood in Vitebsk, rendered in an amalgam of Fauvist and Cubist styles. The circular, faceted structure of *Jew in Bright Red,* with its vigorous, almost electric linear patterns, recalls the organization of *I and the Village.*

The most important of these images of local characters is unquestionably *The Praying Jew* (subtitled *The Rabbi of Vitebsk).* In *My Life,* Chagall recalls the silent, sullen beggar who posed for this portrait. Chagall asked him to come in, saying "You'll have a rest. I'll give you twenty kopecks. Just put on my father's prayer clothes and sit down."[30] Thus he painted this beggar, wearing Zahar Chagall's *tallis* (prayer shawl) and *tefillin* (phylacteries), in the guise of a rabbi at prayer. The result is as powerful a work as Chagall ever created. The composition is dominated by the stark contrasts of black and white, which are moderated by the warm

25

26

103

22

27

24. *Holiday,* 1914
Oil on cardboard, 39⅜ × 31½ in.
Kunstsammlung Nordrhein-Westfalen,
Düsseldorf, West Germany

flesh tones, the touches of red, and the play of subtle pastel hues blended into the lighter areas at the upper left and lower right. The fringed edge of the *tallis* is rendered as a jagged serration, which accentuates the forceful interaction between the black stripes of the *tallis*—here transformed into violent gashes—and the black leather arm bindings of the *tefillin*.

24 The series of works showing Jews at prayer includes *Holiday* (also known as *Festival*), which sets a figure in dark tones against a very plain background, in a scene meant to suggest the harvest festival of Succos (Feast of Tabernacles). The Jew, draped in his *tallis,* is shown holding the *lulav* (palm frond) and *esrog* (citron), ancient symbols of agricultural fertility; he appears ready to enter a tabernacle, or perhaps a synagogue.[31] Above his head stands another draped figure, perhaps meant to suggest the worshiper's pious remembrance of his father and other ancestors. Among Chagall's other series from this diverse period is a group of works

28 depicting acrobats, clowns, harlequins, and other circus figures, subjects long popular with Parisian street painters and well known

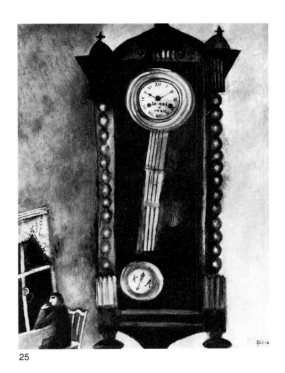

25

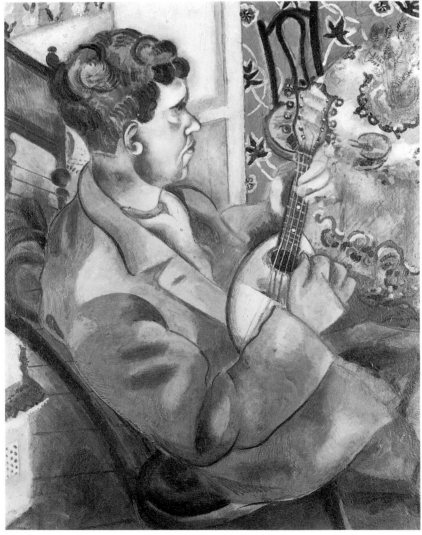

26

25. *Clock,* c. 1914
Oil on cardboard, 18⅞ × 14⅛ in.
Tretiakov Gallery, Moscow

26. *David in Profile (The Mandolin Player),* 1914
Oil on paper, mounted on cardboard, 19⅝ × 14¾ in.
The Art Museum of the Ateneum, Helsinki, Finland

27. *The Praying Jew (The Rabbi of Vitebsk),* 1914
Oil on canvas, 46 × 35 in.
The Art Institute of Chicago;
The Joseph Winterbotham Collection

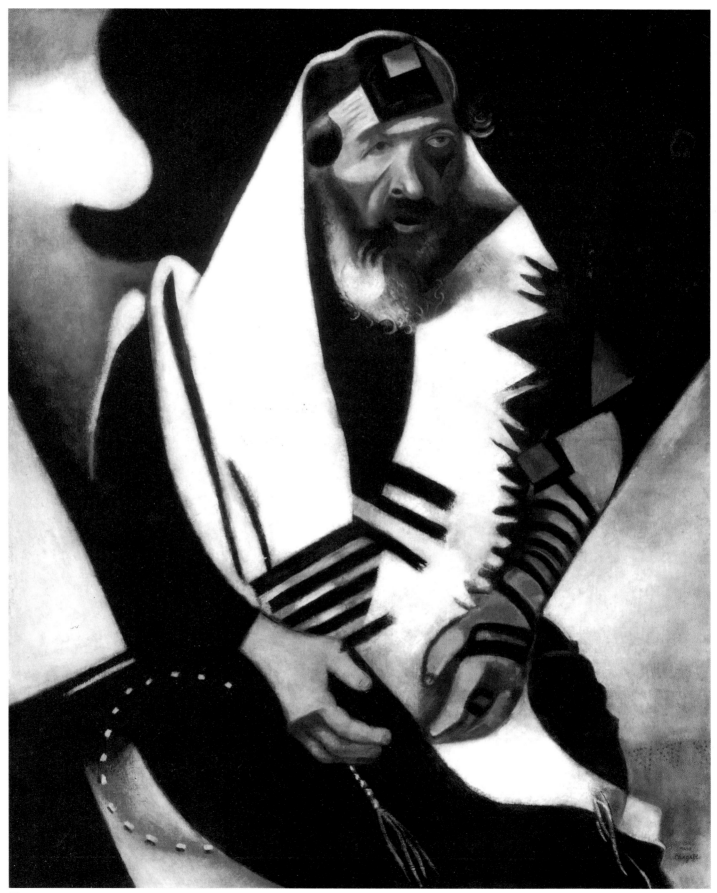

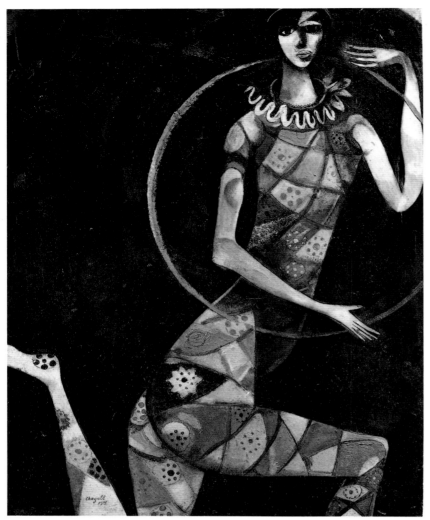

28

in the early work of Picasso. For Chagall, circus figures, like the elderly Jews of his neighborhood, represented the poetry of "beings with a tragic humanity. For me, they are like the figures in certain religious pictures."[32]

The year 1914 was a remarkably eventful one in Chagall's life, and a year of astonishing creative variety. The next year was also to be very significant to him, but for different reasons. In March 1915 he received the first major recognition of his stature in Russia when he was invited to show twenty-five works in an exhibition, *The Year 1915,* held at the Mikhailova Art Salon in Moscow. His submissions, which included *The Praying Jew,* attracted favorable critical attention, and major Russian collectors began to acquire his work. More important still, Chagall now found his renewed love for Bella deepening and maturing. This love became and remained a leitmotiv of his art, an inexhaustible source of romantic wonder for him, and he celebrated it in countless paintings. On July 25 the pair were married at the home of her parents.

It was also during 1915 that Chagall established an important new métier—the medium of ink on paper, basic black and white.

28. *Acrobat,* 1914
Oil on brown paper, mounted on canvas,
16¾ × 13 in.
Albright-Knox Art Gallery, Buffalo;
Room of Contemporary Art Fund, 1941

29. *Strollers,* c. 1915
Ink on paper, 8⅝ × 6¾ in.
Tretiakov Gallery, Moscow

It is the elemental contrast of black and white that gives such expressive force to the oil painting *The Praying Jew*. Now Chagall began to translate that force into the simpler vehicles of graphic art. Was Chagall led to this new medium by the expense and difficulty of obtaining good paints under wartime conditions, as he had been led to the use of cardboard and paper rather than canvas? Whatever the reason, he found that he possessed a powerful sense of graphic composition and a natural gift for illustration. Between 1915 and the early 1920s strikingly original, diverse, and experimental creations poured forth from Chagall's pens and ink brushes. Although these works initially took the form of drawings, they were to provide the basis for Chagall's notable later career as printmaker and book illustrator. Indeed, many of the early drawings, such as *Strollers*, have the character of German Expressionist woodcuts. Other drawings, such as those executed 29

29

in 1916 as illustrations for tales by the poet-fabulist Der Nister, have an innovative, at times whimsical quality that seems to reflect Chagall's exposure to illustrations in medieval *Haggadahs*.

With the expiration of his military deferment, Chagall faced the problem of war duty. Turned down in his request to be a camouflage painter, he once again found a guardian angel; this time it was his wife's brother, an attorney who directed the War Economy Bureau in Petrograd (as Saint Petersburg had recently been renamed). A sinecure office position was found for Chagall, who spent most of his time jotting notes toward an autobiography and getting to know critics, writers, poets, political thinkers, and other artists—acquaintances who were soon to serve him well.

The spring of 1916 saw the birth of Chagall's daughter, Ida. During the summer of 1917 Chagall rented for his new family a cottage in the countryside near Vitebsk, and then they spent some months in their hometown. From this period emerged a series of paintings of Vitebsk and its surroundings that rank among Chagall's finest landscapes. Included in this series are *The Blue House* and *Cemetery Gate*. A major work in a fragmented Orphic Cubist style, *Cemetery Gate* is an evocative painting of remembrance and the romantic suggestion of decay and rebirth. The explosion of the blue planes of the sky suggests the upward thrust of resurrection, a concept echoed in the biblical texts inscribed in Hebrew on the gate piers, which prophesy the rebirth of the departed. This vision of death and rebirth seems apt for the year 1917, for it was then that the ancient dynasty of the Romanoff czars collapsed in Russia. Following the brief tenure of the Social Democratic party under Aleksandr Kerensky came the revolution of Lenin and the Bolsheviks, and the birth of what was to become the USSR.

For Chagall personally, the Revolution led to events that, given his prior experience, were quite astonishing. It might be said that revolutions are created by dreamers, but successful revolutionaries must also, obviously, be committed to practical action. For his whole life Chagall had been a dreamer, an artist-bohemian utterly detached from the politics and commerce of daily life. But now the vision of a new order, a socialist utopia that seemed at the outset to promise full enfranchisement for the Jews and full support for progressive movements in art, galvanized this private, poetic muser into an almost manic state of public activism. In August 1918, less than a full year after the Revolution, Anatoly Lunacharsky, who had befriended Chagall in Paris and was now People's Commissar for Education and Culture, approved a project by Chagall to establish an academy of art in Vitebsk. Other friendships he had formed during his time in Petrograd now provided an additional base of political support, and on September 12 Chagall was appointed Commissar for Art in the reorganized government of his hometown.

In his new post Chagall promptly undertook an ambitious program of exhibitions and large-scale public art projects, as well as the founding of his academy and a museum. He seized the nationwide celebration of the first anniversary of the Revolution on November 6, 1918, as an occasion to decorate the entire town of

Vitebsk with hundreds of banners and flags. A legion of artists was enlisted to carry out this task under his direction, and, not surprisingly, the overall flavor of the imagery was very much à la Chagall.

Chagall's energies during the latter part of 1918 and most of 1919 were largely directed toward the political battles necessary to obtain funding and governmental support for his academy and other visionary projects. His polemics, his battles with local politicians, his publicity campaigns, and his shuttling back and forth to Petrograd and Moscow to enlist and maintain support are almost humorous, suggestive of comic operetta. But on January 28, 1919, the Vitebsk Academy officially opened under Chagall's direction. During the brief existence of this institution, its faculty was to include El Lissitzky and Kasimir Malevich, two of the leading figures within the Russian avant-garde.

Chagall's second triumph of 1919 came at the *First National Exhibition of Revolutionary Art,* held in Petrograd from April to July. Hundreds of artists were represented, but Chagall was granted pride of place, with two rooms all to himself. A dozen of the works he showed were purchased by the government and so entered the national collections of the Soviet Union. Chagall's art from 1917–19 displays, for the first time, a willingness to experiment with the radically flat, simplified geometry of Russian Constructivism. Early in the second decade of the century Malevich, along with Mikhail Larionov and Natalya Goncharova, had formed a group they named the Jack of Diamonds. These artists were at the very forefront of European modernism. Indeed, Malevich's Suprematist paintings of 1913—consisting, in some instances, of nothing more than a white or black square on a white background—were as dramatically innovative as anything being created in Paris, and his works laid the foundation for the Constructivist movement in Russia, which was later developed by Vladimir Tatlin, Aleksandr Rodchenko, Aleksandr Archipenko, and others. During the first years of the new Soviet regime, Constructivism was ascendant as the prevailing medium for public art and propaganda. Its practitioners were officially in favor, and they were the main beneficiaries of the government's patronage and commissions.

In paintings such as *Composition with Goat, Chagall,* and *Profile at the Window,* Chagall explored the flat, simplified geometries of Suprematism and Constructivism. But, inevitably, his whimsical figures enter the pictures, lightening the purist tone of these modernist doctrines and supplying his characteristic touches of humor. These paintings also display Chagall's new graphic sensibility, which he had already begun to apply in his public art projects, such as banners and murals. It shows as well his corollary interest in Hebrew and Cyrillic calligraphy, whose formal concepts he had begun to use in his book illustrations and other graphic work, at times rendering human and animal figures almost as if they were letters of the alphabet.

At the same time Chagall continued to work in several other veins, even continuing his portrait drawings. *Cubist Landscape,* a major work of this era (dated 1918, but according to Meyer

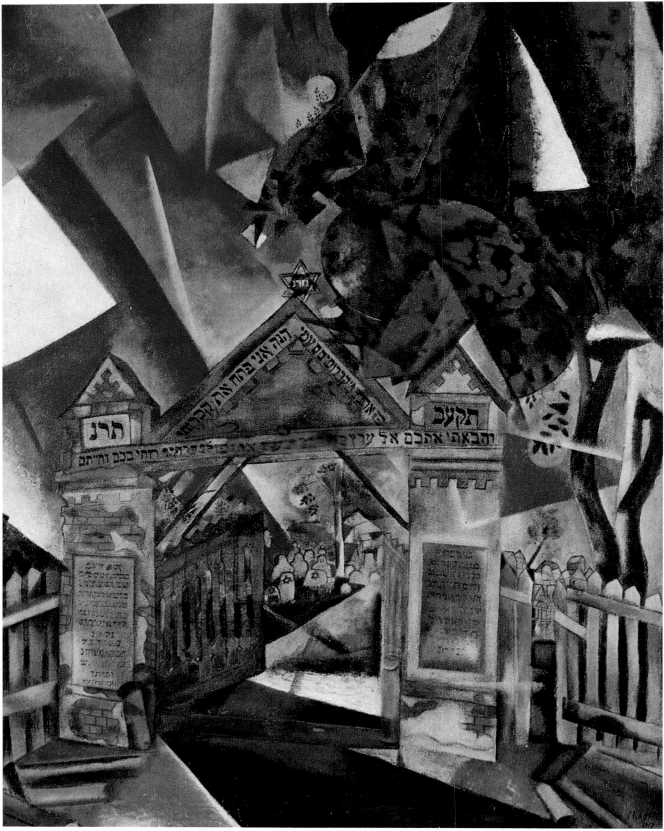

30

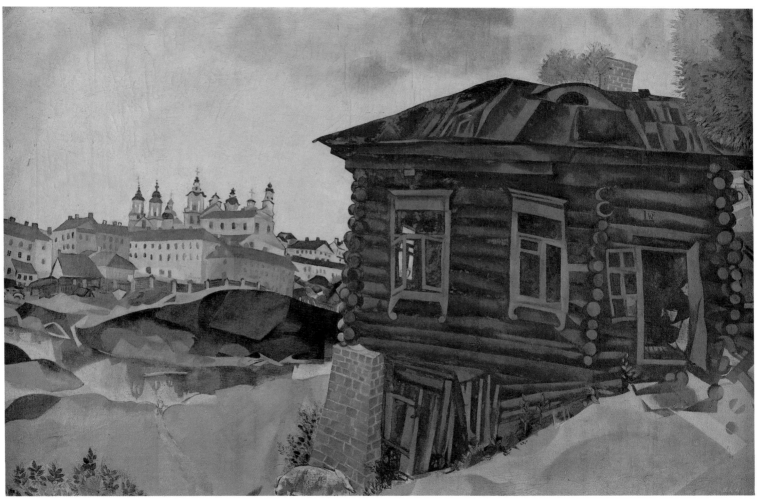

31

30. *Cemetery Gate,* 1917
Oil on canvas, 34¼ × 26⅞ in.
Private collection

31. *The Blue House,* 1917
Oil on canvas, 26 × 38¼ in.
Musée d'Art Moderne, Liège, Belgium

32

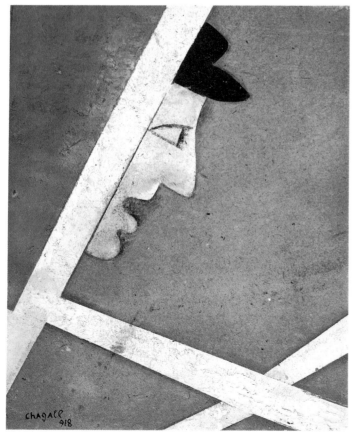

33

32. *Composition with Goat,* 1917
Oil on carton, 14⅜ × 19¼ in.
Private collection

33. *Profile at the Window,* 1919
Oil on cardboard, 8⅝ × 6½ in.
Musée National d'Art Moderne,
Centre Georges Pompidou, Paris

34. *Cubist Landscape,* 1918
Oil on canvas, 39⅜ × 23¼ in.
Musée National d'Art Moderne,
Centre Georges Pompidou, Paris

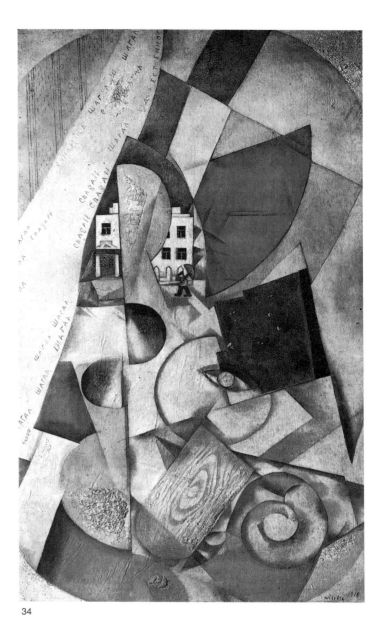

34

executed in 1919), is in the Synthetic Cubist style invented a few years earlier by Picasso and Braque. Chagall even introduces, after the French manner, a section of fake wood painted in the lower center. At the left is a passage in which Chagall was playing word games with his own name, as he frequently did, transliterating it into Hebrew, Cyrillic, and Latin characters. Near the center of the painting is depicted the white house (confiscated from a banker) that served as the Vitebsk Academy.

By the middle of 1919 Chagall's experience as commissar and academician had already begun to go sour. Within his own academy, factions around Malevich and Lissitzky began to agitate against the dominance of Chagall's art, with its fantastic, whimsical visions. At the same time, an antimodernist sentiment was growing in the Communist party, favoring a more explicitly illustrative, more blatantly propagandistic form of art—which would come to be known as social realism. Confronted with conflicts on all sides, Chagall resigned his commissariat by mid-1919, and early that autumn he abdicated the directorship of the academy

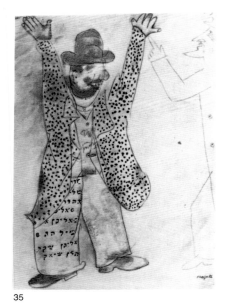

35

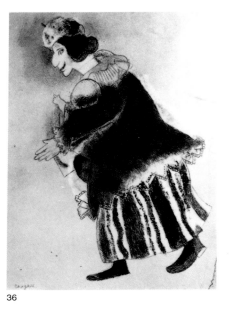

36

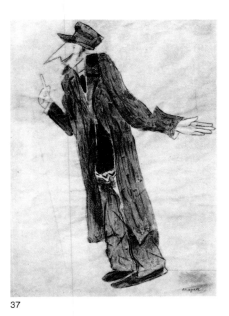

37

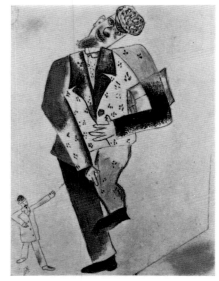

38

he had founded. A "counter-revolt" by his supporters at the Academy reinstated him, but his return was short-lived. Like many modernist artists, Chagall seems to have mistakenly envisioned the Communist revolution as a victory for individual freedom and conscience. But most of those optimists were to discover, to their dismay, that the realities of collectivism were something very different. Chagall had rather naively imagined that his idiosyncratic style of art could provide emblems for the new socialist utopia. His illusions were quickly shattered. By 1920 Chagall's meteoric career as public official, political activist, and academician had come to an end.

In May 1920 Chagall, along with his wife and daughter, left Vitebsk and took up residence in Moscow. This marked the beginning of another period of great hardship. Chagall had fallen from official favor, and the 1919 state acquisitions of his work were to be the last. He was reduced to severe poverty at a time of general impoverishment in Russia. The Chagall family lived in a single unheated room, and they were forced to scavenge for food. Still, Chagall's cheerful spirit appears to have been little affected. In 1921 the former art commissar was given a new post by the government, as art teacher in a colony of war orphans in the Moscow countryside. His dignity was little impaired by the reduction in circumstances, and he came to enjoy his new position, developing great affection for his students.

Chagall's stay in the Moscow area from 1920 to 1922 also marked the inception of a third major area in his career, alongside painting and illustration—that of theater set design. He found support for this direction from Bella, who had studied drama during her school years and retained an active interest in theater. In mid-1919, while still in Vitebsk, Chagall was asked by the director of the Moscow Theater of the Revolutionary Satire to design costumes and scenery for a production of *The Inspector General*, by the renowned Russian satirist Nikolai Gogol. Chagall's sketches display his interest at that moment in synthesizing Constructivist geometries with his personal iconography and fan-

35. *Costume Sketch for Sholem Aleichem's "The Miniatures"*
Pencil and crayon with gouache on paper, 10⅞ × 7⅞ in.
Estate of the artist

36. *Costume Sketch for Sholem Aleichem's "The Miniatures"*
Watercolor on paper, 11 × 7½ in.
Estate of the artist

37. *Costume Sketch for Sholem Aleichem's "The Miniatures"*
Pencil and gouache on paper, 11 × 7½ in.
Estate of the artist

38. *Costume Sketch for Sholem Aleichem's "The Miniatures"*
Pencil, ink, and watercolor on paper, 11 × 7½ in.
Estate of the artist

39. *Set Design for Sholem Aleichem's "The Agents,"* 1919
Pencil and watercolor on paper, 9⅞ × 13⅜ in.
Estate of the artist

40. Set for Sholem Aleichem's "The Agents," 1919

tasy. That theatrical project was never realized, but in 1920 Chagall was commissioned by the Kamerny Theater in Moscow to prepare sets and costumes for a short play based on Sholem 39, 40 Aleichem's story "The Agents." Totally sympathetic with this Yiddish writer's vision of a tragicomic, slightly farcical world of Hasidic Jewish culture, Chagall immersed himself in every aspect of

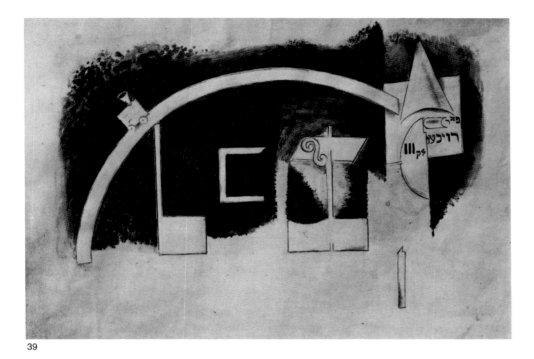

39

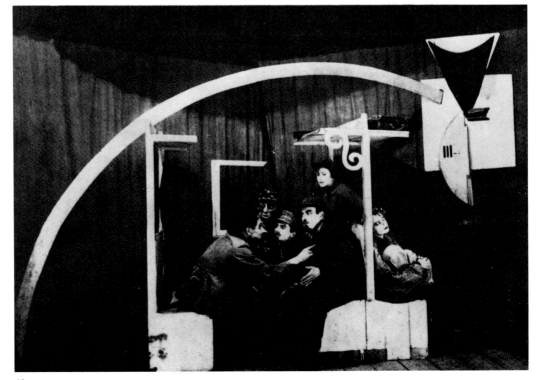

40

the production, even overseeing the actors' makeup. At times he almost usurped the roles of the director and the producer, which inevitably resulted in conflicts. However, early in 1921 the play opened to great success. Chagall's interpretations of Jewish types and mannerisms were recognized as one of the prime influences on the style of this company when it later began to tour the world.

Also in 1921 Chagall produced costume and set sketches for a Stanislavsky Theater production of J. M. Synge's *Playboy of the Western World,* but these were rejected because of their lack of "naturalism." The most important of Chagall's early works connected with the theater were the immense murals he created for permanent installation in the Kamerny auditorium. The canvas 41 for *Introduction to the Jewish Theater* was approximately nine by twenty-six feet, Chagall's largest painting up to that time. This dramatic work is not only a summation of various aspects of Jewish theatrical culture but also a kind of summation of Chagall's art. Hanging opposite this canvas in the auditorium were four individual panels representing Jewish music, dance, theater, and literature. In the allegory of music, a theme Chagall repeated p. 2 in the animated *The Green Violinist,* appears once again his fiddler on the roof, that stock character preserved from the world of the *shtetl* by Chagall and Sholem Aleichem.

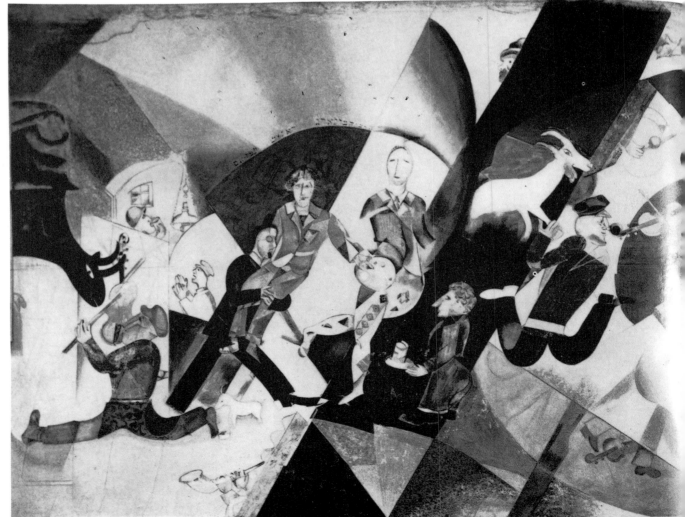

41

In 1922, his final year in Russia, Chagall created another summary of his life and career, this time in the form of a literary testament—the autobiography he later published under the title *My Life*. By this time Chagall had foreseen his departure from Russia, or at least his attempt to depart. Disillusioned by the course of events in Soviet society, even the irrepressible Chagall walked the streets of Moscow "in despair."[33] He had started a memoir of his childhood in 1911; and additional notes had accumulated during his tenure at the War Economy Bureau. Now he began in earnest to recount his story and to conceive a suite of images to illustrate it.

In 1922, as now, it was no simple matter to emigrate from the Soviet Union. But, as always, Chagall had guardian angels standing by. In the summer of that year Lunacharsky obtained a passport for Chagall to leave, and it was arranged for Bella and Ida to follow a few months later. A loyal patron named Kagan-Shabshay, who had been collecting Chagall's art since the artist's return to Russia in 1914, provided funds for the journey. Taking a substantial cargo of pictures and the nine notebooks that held the manuscript of his autobiography, Chagall traveled to the border city of Kaunas. From there he left his native country for a second time, not to return for more than half a century.

41. *Introduction to the Jewish Theater,*
1920–21
Oil on canvas, 9 ft. 3½ in. × 25 ft. 11 in.
Tretiakov Gallery, Moscow

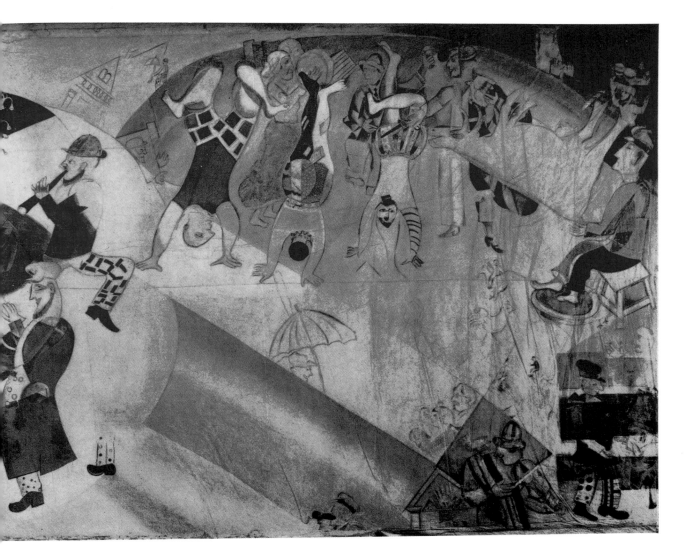

4 Berlin to Paris

Chagall reached his first destination, Berlin, to find himself something of a celebrity. Berlin was then at the very height of the postwar libertinism and decadence in which all the arts thrived so brilliantly, and Chagall became one of its stars. After his fall from grace in Russia, this prominence must have been a welcome source of gratification. Unfortunately, this was also a period of catastrophic inflation in Germany, which seriously diminished the triumph of Chagall's return. Herwarth Walden, Chagall's dealer in Berlin, had had no contact with the artist since 1914, and rumors had circulated that Chagall had died in the war or the Revolution. Walden had nonetheless continued to exhibit and sell the works Chagall had consigned to him, depositing the revenues in escrow with an attorney. That sum was now paid to Chagall, but inflation had rendered it worthless. Furthermore, because Walden felt obliged to maintain the confidence and anonymity of his clients, he refused to reveal to the artist the identity of many of the purchasers of his works. Chagall felt as though he had been robbed of his own history and work, and he instituted a lawsuit against Walden. The issue was not settled until 1926, when some of the works were returned to him.

A happier event of Chagall's stay in Berlin was the proposal from the dealer and art historian Paul Cassirer to publish the artist's autobiography, to be illustrated with a suite of twenty etchings and drypoint engravings. As it turned out, translation difficulties prevented publication of the text, which did not appear in print until 1931, in a French edition titled *Ma Vie*. However, Cassirer did publish the suite of engravings by themselves, and this opened up yet another fertile new field—printmaking—in Chagall's career. While in Berlin, Chagall also began to make lithographs, inaugurating his role as one of the most prolific printmakers of this century.

Chagall and his family remained in Berlin until August 1923, when he obtained a visa to emigrate to France. On September 1 he arrived again in Paris. It has been written of Chagall's return that "the French miracle was repeated," that Chagall rediscovered "the spiritual air of freedom in which the artist's personality is heightened."[34] Whatever the truth of this assertion, Chagall's en-

42. *Equestrienne (Zirkus)*, 1927
Oil on canvas, 39⅝ × 31⅞ in.
Narodni Galerie, Prague

suing fifteen years in France formed the happiest, most peaceful period of an exceptionally happy life. He later declared that he had returned to France because he felt it to be his "real homeland."[35] At first the Chagalls found lodging in a strange medical clinic where empty rooms were rented out to poor artists. Soon, however, they found a cozy studio on the avenue d'Orléans, which they fitted out with pleasant exotica.

Ironically, Chagall's arrival in Paris was marred by an unpleasant discovery similar to that which had greeted his arrival in Berlin. When he had left his studio in La Ruche in 1914, expecting to return shortly, he had padlocked and wired his door in order to guard his paintings and materials. Shortly after his return to Paris nine years later, he went to La Ruche, rather naively expecting to find his studio intact. What he found instead was another artist occupying the space, and all his possessions gone. It turned out that his works and supplies had been sold off, item by item, by his friends and acquaintances, who never expected to see him again.

Chagall was anguished but not paralyzed by this double loss. In the years 1923–26 he embarked on a remarkable program of recreating the lost works of his breakthrough years in Paris. He wanted to fill the disturbing void in his oeuvre and life, but there may also have been an element of revenge in his actions, for collectors who had acquired his works under somewhat questionable circumstances were now dismayed to see "authentic replicas" of their paintings, such as *I and the Village* and *The Reading*, ap-

44, 45

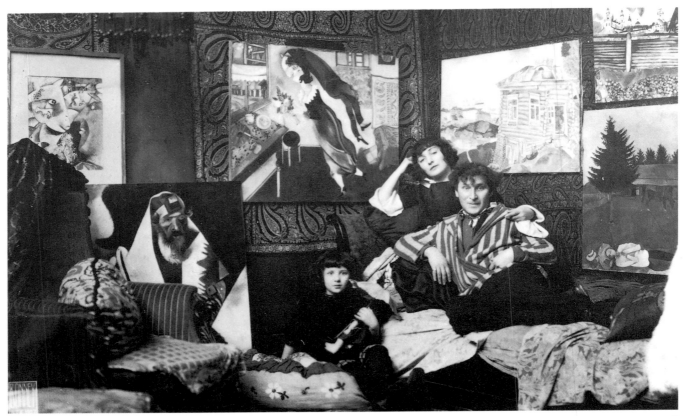

43

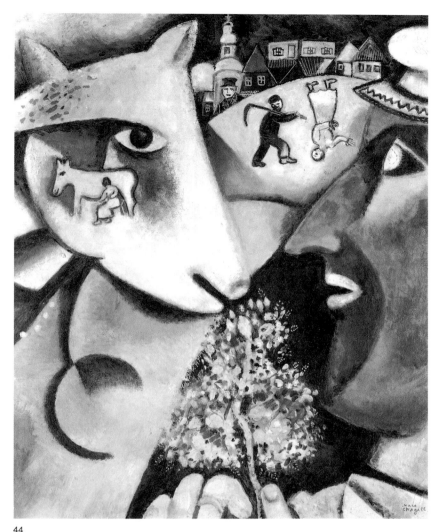

44

pearing in the art market. This Paris "miracle" thus began not with the birth of a new style but with a repetition of an old one and with the reaffirmation of an established aesthetic identity. In a sense, Chagall continued to recreate those works to the end of his life, for the basic iconography and structures of his art were to change very little from this time forward. Although he continued to explore new media, his oeuvre was, for the most part, a long series of variations on his existing repertory of images.

This was a period of unrivaled happiness and contentment for Chagall. He and Bella were able to discover the joys of traveling throughout France, where the artist fell in love with the varied landscapes and the distinctive effects of light. These journeys yielded works with a brilliant new illumination and an unprecedented airiness, as in *Ida at the Window* and *The Window on the Island of Bréhat*. There also appeared paintings of intense color and lyric forms, such as *Lovers with Flowers*, which express the renewed spirit of romance and youthfulness that he and Bella found in their pleasant new circumstances.

Chagall's return to Paris coincided with the emergence of the Surrealist movement in art and literature, led by the poet André

43. Marc, Bella, and Ida Chagall in Chagall's studio on the avenue d'Orléans, Paris, c. 1923

44. *I and the Village*, 1924
Oil on canvas, 21¾ × 18¼ in.
Philadelphia Museum of Art; Given by Mr. and Mrs. Rodolphe M. de Schauensee

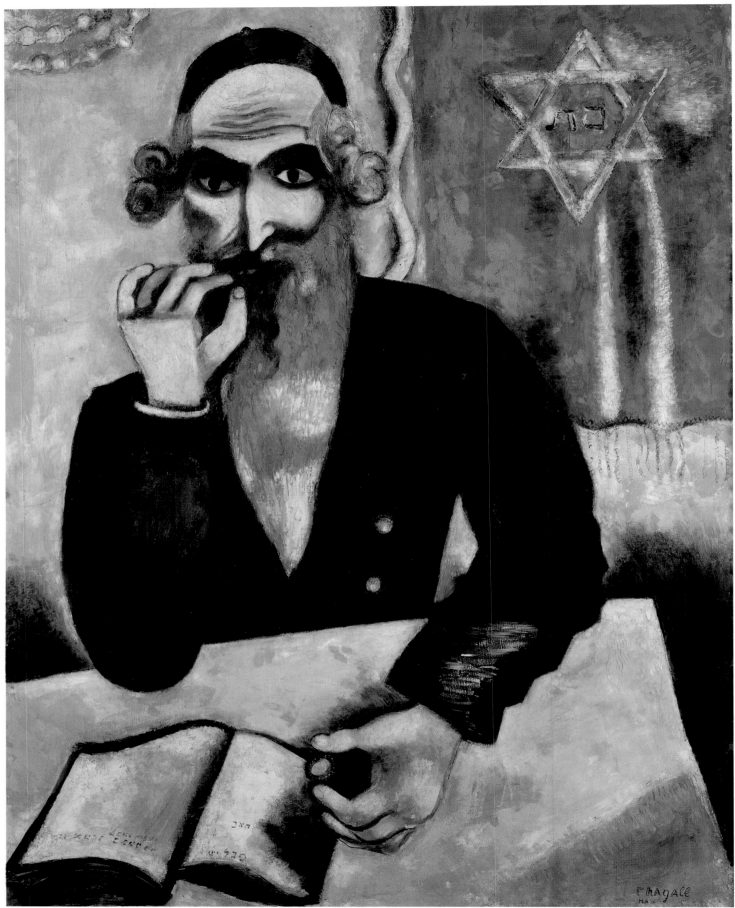

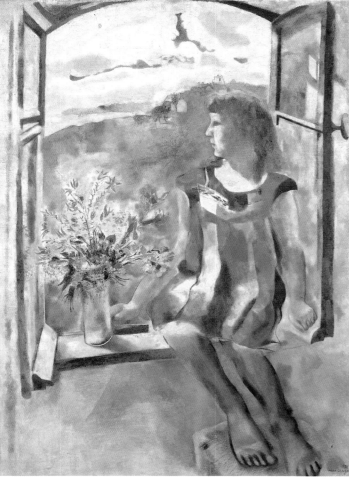

46

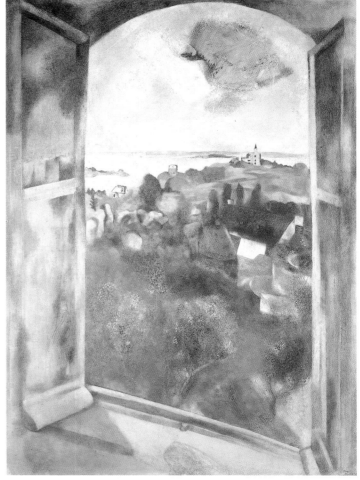

47

45. *The Reading,* 1923–26
Oil on canvas, 46⅞ × 35⅛ in.
Offentliche Kunstsammlung, Kunstmuseum
Basel, Basel, Switzerland

46. *Ida at the Window,* 1924
Oil on canvas, 41⅜ × 29½ in.
Stedelijk Museum, Amsterdam

47. *The Window on the Island of Bréhat,*
1924
Oil on canvas, 39 × 30¾ in.

48. *Lovers with Flowers,* 1927
Oil on canvas, 39⅛ × 35 in.
Israel Museum, Jerusalem; Gift of Baron
Edmond de Rothschild, Paris

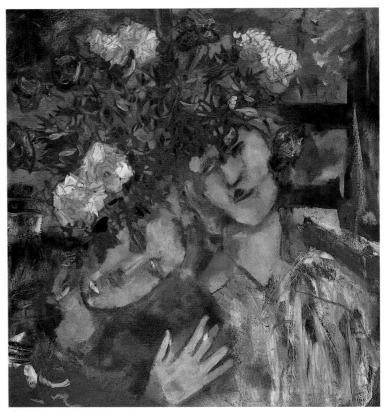

48

49

Breton. The Surrealists heralded Chagall as a prophetic synthesizer of poem and image and a pioneering explorer of the antirational realms of dream, fantasy, and imagination. Chagall was flattered by this lionization and initially subscribed to the Surrealist program. However, he quickly broke with that movement, repudiating its doctrines as excessively literary and antithetical to art as he understood it.

A far more productive encounter was with the famous art dealer Ambroise Vollard. Chagall recalled having been intimidated during his prewar years in Paris by this powerful dealer in Impressionist, Fauvist, and Cubist paintings. But now it was Vollard who approached Chagall with a proposal. Vollard had earned an important secondary reputation as a publisher of limited-edition books elegantly illustrated by famous artists such as Picasso and Matisse. Contacting Chagall through the poet Cendrars, Vollard commissioned a suite of 107 etchings to illustrate the renowned Gogol novel *Dead Souls*. Chagall had already had experience in designing the sets and costumes for a Gogol play; he had also produced drawings for Der Nister and the suite of autobiographical prints for *My Life*. But it was with the prints for *Dead Souls*, produced in 1923–25, that Chagall's career as a major book illustrator began in earnest. This work also provided the artist with a welcome steady source of income, as well as the imprimatur of Vollard, which excited the interest of collectors and other dealers.

Curiously, Vollard showed no immediate interest in publishing the book or the plates. He merely stacked them in his storeroom with his hoard of works by other major artists. Yet even though *Dead Souls* with the Chagall illustrations was not published until 1948, the project must be considered a major success and an important step in Chagall's career. "In *Dead Souls* Chagall saw the Russia he had known, with all its misery and magnificence, elation, and despair. His own experience, too, namely his initial

49. *Escape in Nature's Garb* (Illustration for Nicolai Gogol's *Dead Souls*), published 1948
Etching, 8¼ × 10⅞ in.
The Art Institute of Chicago; Gift of Print and Drawing Club

50. *The Satyr and the Wayfarer* (Illustration for La Fontaine's *Fables*), 1925–27
Gouache on paper, 19¾ × 16 in.

Pages 58–59:
51. *Equestrienne,* 1931
Oil on canvas, 39⅜ × 31⅞ in.
Stedelijk Museum, Amsterdam

52. *Birthday,* 1923
Oil on canvas, 31⅞ × 39½ in.
Solomon R. Guggenheim Museum, New York

53. *Solitude,* 1933
Oil on canvas, 40⅛ × 66⅛ in.
Tel Aviv Museum of Art; Gift of the artist

triumph and subsequent disappointment in the years of the revolution, the broadness and narrowness, the extravagant idealism and paltry meanness of the Russian world, are summed up for him in the famous novel."[36] Although Vollard did not publish these etchings, he must have been satisfied with them, for he next commissioned Chagall to execute a suite of prints to illustrate the *Fables* of La Fontaine (first published with the Chagall illustrations in 1952). This well-publicized commission caused a minor furor in France over the fact that the privilege of illustrating the work of an important French writer should be granted to a recent immigrant, a Russian Jew. Subsequently, Vollard contracted with Chagall to create what would prove to be the crowning achievement of his career as an illustrator—namely, a series of etchings to illustrate an edition of the Bible (published by Tériade in 1956).

50

In addition to his book illustrations, the scenes from his travels, and the romantic portraits of himself and Bella, the works most characteristic of Chagall's second Paris period are his paintings of circuses and circus figures. From 1924 on, Chagall became a habitué of the circus, attending with his daughter or with Vollard as often as three times a week. This was apparently a source of great

52

42, 51

50

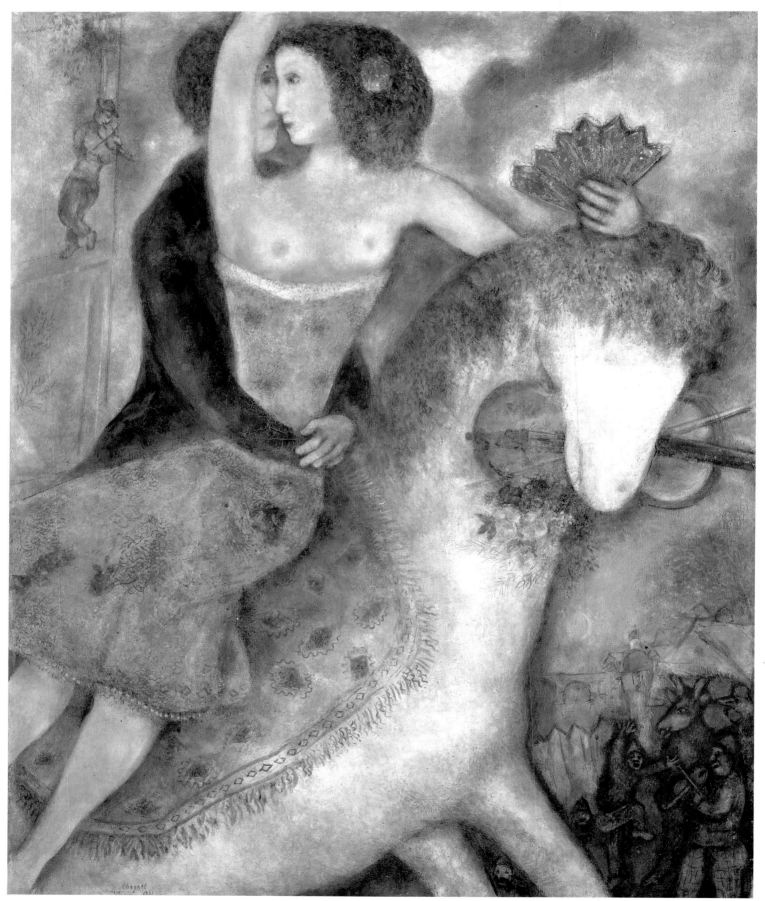

58

52

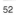

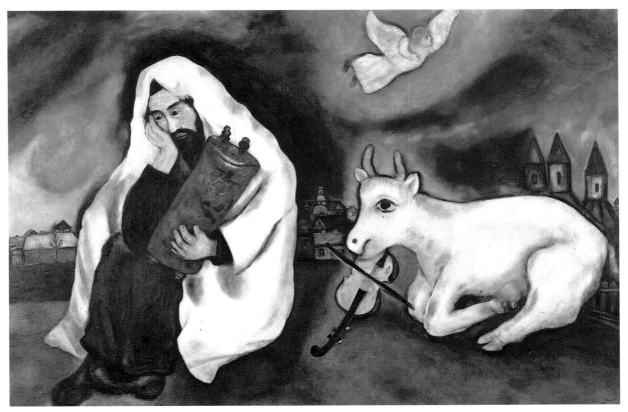

53

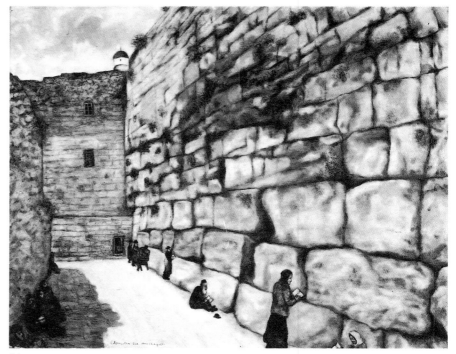

54

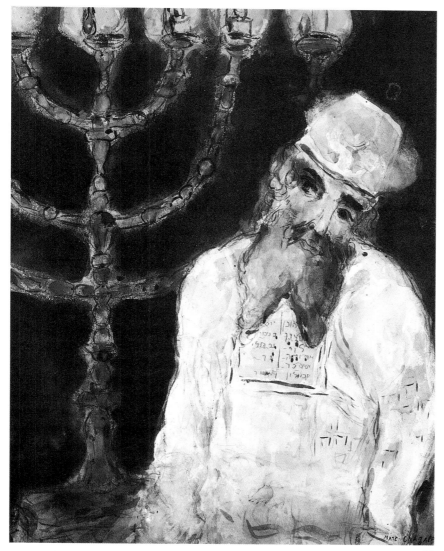

55

56

pleasure and visual stimulation for the artist. Although circus figures had occasionally appeared in his work before the war, henceforth these "tragic, religious, poetic" beings (as Chagall characterized them) would form a constant and brilliantly colorful element in his iconography.[37]

The story of Chagall's years in France reads like a romantic travelogue, as the family moved from Savoy through the Alps to the Mediterranean coast, and on and on. The most significant of Chagall's journeys during this period was his trip to Palestine in the early months of 1931. It was in 1930 that Vollard had commissioned the illustrations for the Old Testament. Although the aging dealer had suggested that Chagall could get sufficient inspiration from a trip to the place Pigalle, the artist felt the need to breathe the air of the Holy Land and to view for himself its scenery and light. This was to prove one of the major experiences of his life. Everywhere he was welcomed by dignitaries as a Jewish celebrity. In Tel Aviv, Jerusalem, and Safad he painted gouaches of ancient synagogues, cityscapes, and landscapes dense with history and tradition. These were simple representational "documents," in the manner of the Vitebsk paintings of 1914. It was here, too, that he began the moving gouaches that were to serve as the basis for his biblical etchings. In these remarkable images, such as *Aaron before the Candelabrum*, Chagall adopted what 55 was to be his last major variation in style. These figures are rendered with a heightened expressionism, the undulant lines so dominating the color effects that the softened hues are reduced to a supporting role. The effective and affective illustration of these biblical themes—so much a part of his background—became Chagall's primary goal.

Throughout their years together Chagall never ceased to delight in painting portraits of his wife. Among the many images of Bella from the 1930s are two that merit special mention, *Angel with* 57 *Red Wings* and *Bella in Green*. In the former Chagall has synthe- 58 sized the faces of his wife and daughter into a vision of his guardian angel and muse, who towers over a figure of the artist at the

54. *The Wailing Wall*, 1932
Oil on canvas, 28⅜ × 36¼ in.
Tel Aviv Museum of Art

55. *Aaron before the Candelabrum*, 1931
Gouache and oil on paper, 24⅜ × 19¼ in.
Musée National Message Biblique Marc Chagall, Nice, France

56. Chagall painting in Palestine, 1931

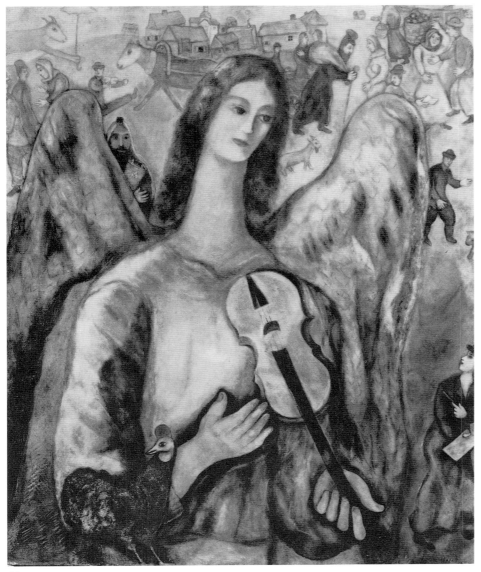

57

lower right, while the figures from a Vitebsk marketplace parade in the background. *Bella in Green*, whose creation is documented by a remarkable photograph, is a strangely formal portrait—related in spirit to the portraiture of late sixteenth-century Italy and early seventeenth-century Holland. The figure of Bella appears elegant, almost stiff, rich with the deep green velvet of her dress, enlivened by the lacework of her collar, cuffs, and fan. It is as if Chagall wished to fix this image of his beloved in an ancient past, in order to immortalize his love for her and thus preserve it from the transformations wrought by time.

Indeed, by the mid-1930s there was ample reason for Chagall to become anxious about time's passage. The Nazi turmoil agitating central Europe may have suggested to him that his idyll in France was approaching its end. *Time Is a River without Banks*, a major painting from this period, seems to declare such concerns in imaginative metaphor.[38] The clock, a conventional symbol of the passing hours, is the living-room clock from Chagall's parents'

57. *Angel with Red Wings*, 1933–36
Oil on canvas, dimensions not available
Estate of the artist

58. *Bella in Green*, 1934–35
Oil on canvas, 39⅜ × 31⅞ in.
Stedelijk Museum, Amsterdam

59. Bella Chagall posing for *Bella in Green*, 1934

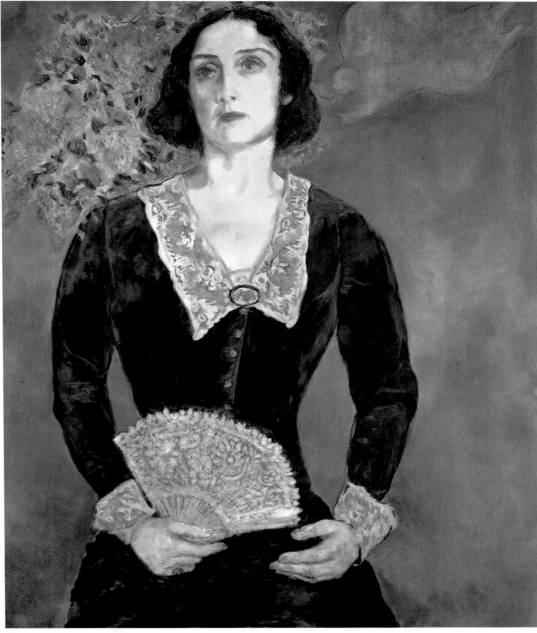

58

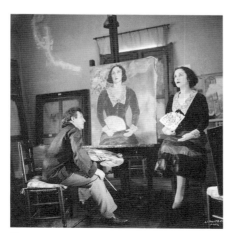

59

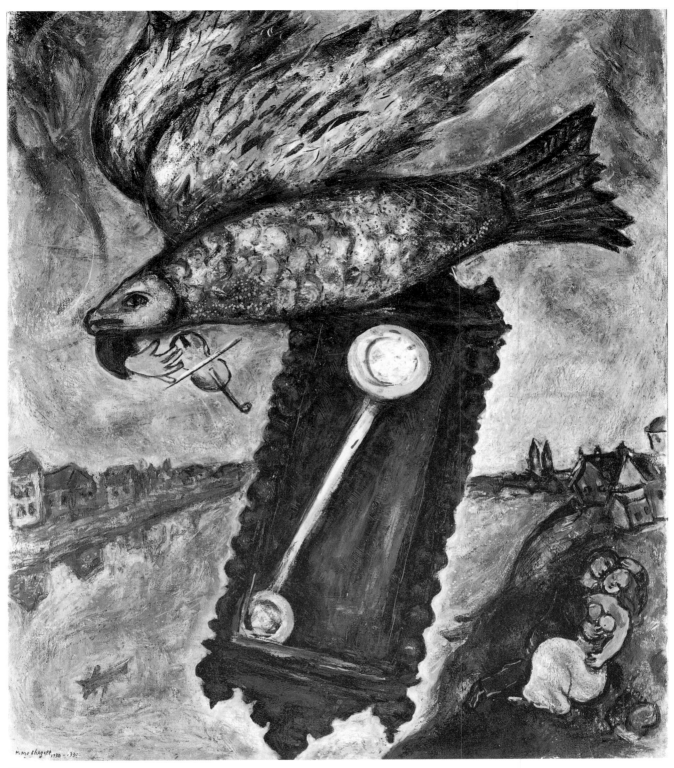

60

house in Vitebsk, a temporal image he had earlier used in the
melancholic *Clock* of about 1914 and other works. Here lovers
embrace in blue twilight on the banks of a river (presumably the
Dvina in Vitebsk), while music is provided by a curious flying fish-
angel with fiery red wings and a violin. This painting—with its
curious timepiece, its bizarre juxtapositions, and its aura of
haunted revery—appears to echo in certain ways Salvador Dali's

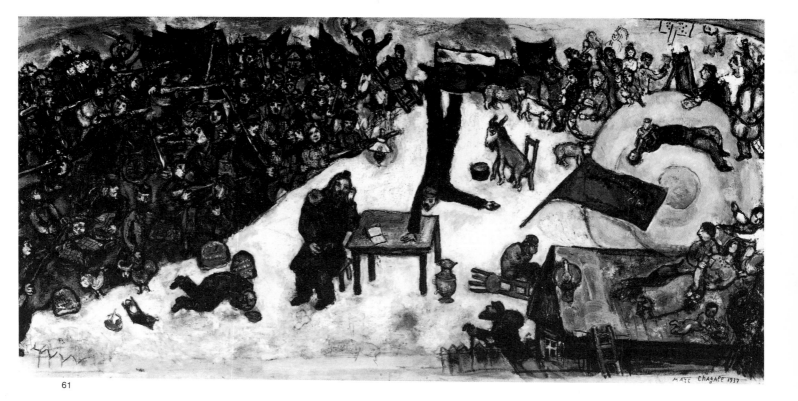

61

famous *Persistence of Memory* (1931); and it illustrates rather explicitly Chagall's links to Surrealism.

A more direct expression of the social and political upheaval in Europe during the late 1930s is the monumental painting entitled *The Revolution*. This canvas, which Chagall continued to rework for many years and finally cut into three sections, was originally about five feet high by twelve feet long. He had not worked on such a large scale since producing his murals for the Jewish theater in Moscow during the early 1920s. *The Revolution* was clearly intended to be a major work. Often, when an artist senses some significant change impending in life or work, there arises the impulse to create a synthesis of all that has gone before. *The Revolution* is such a compendium of images from Chagall's memory and imagination.

The left half of the picture is an extremely dense multifigure composition showing the Russian masses in the uprising of 1917, carrying rifles and waving their red banners. This image was at once a recollection for Chagall of his own Revolution, a declaration of sympathy with the revolutionaries then fighting the Spanish Civil War, and an intimation of the world war soon to come. At the center of the painting is Lenin, the visionary activist, who leads his troops with a very strange gesture—he performs a handstand on a table. Meanwhile, an old Jew in phylacteries sits praying, studying, thinking (perhaps in counterpoint to the acrobatics of Lenin). At the right side of the picture, the painter at his easel overlooks the scene, with his bride, Bella, behind him. Surrounding the artist are his beloved goats and chickens, Jewish peddlers and beggars around a Vitebsk cottage, flying figures, and even the "sun disks" of Robert Delaunay. Like most people throughout Europe in 1937, Chagall could sense the tremors of the cataclysm about to occur, and this was his preliminary response.

60. *Time Is a River without Banks,* 1930–39
Oil on canvas, 39⅜ × 32 in.
Collection, The Museum of Modern Art, New York; Given anonymously

61. *Study for "The Revolution,"* 1937
Oil, gouache, and pastel on canvas,
19⅛ × 40⅛ in.
Musée National d'Art Moderne,
Centre Georges Pompidou, Paris

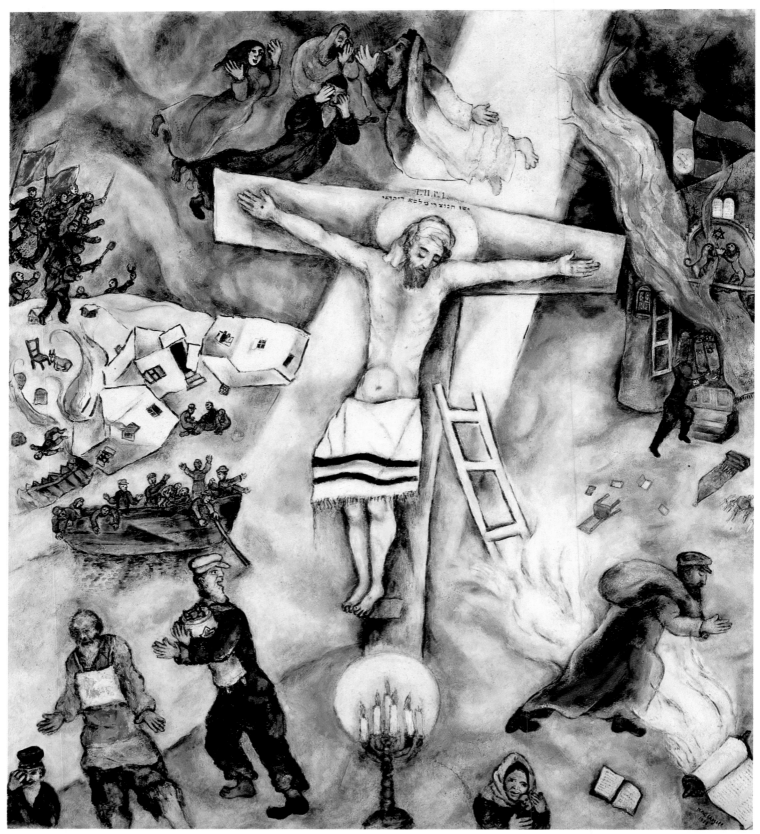

62

5 War and Exile

In 1938 Chagall's art underwent far more profound changes in response to the crises in Europe. Reports of Nazi atrocities against Jews were filtering into France. Chagall had been condemned by the Nazis as a Jew and a Bolshevik. His works were labeled "decadent" and removed from German museums; many were destroyed. Paintings such as *White Crucifixion* express an anguish unprecedented in Chagall's oeuvre. Flowers are replaced by flames; bright, delicate, airy hues are supplanted by dark, somber, intense shades. At the upper left is a scene of armies on the march, taken from *The Revolution.* Around the central image of a crucifixion, Jews flee in terror from burning houses and synagogues as their world is destroyed in a holocaust. A Nazi soldier invades a synagogue at the upper right, to desecrate it and set it on fire. Floating above the Christ figure are Jewish ancestors, patriarchs and matriarchs, who look on in despair.

This image of Christ and the crucifixion was quite new in Chagall's art. In 1912 he had painted a scene of Golgotha, and a few images related to icons and other forms of Christian art preceded it in his youthful experiments. After 1938 the image of Christ on the cross became a stock figure in Chagall's iconography. These images also had formal sources in Chagall's youthful experience of medieval Russian icons and particularly in his encounter with the icon painter Rublev, whom Chagall greatly admired, calling him a Russian Cimabue.[39] However, his is an image of Christ as never before rendered in art. It is not a Christian image of Christ but a distinctly Jewish one, in which Christ's identity as a Jew is emphasized above all. Thus, for example, the loincloth worn by this figure is unmistakably formed from a *tallis,* the traditional Jewish prayer shawl.

The ritual breast cloth worn by the poor Jew at the lower left of the *White Crucifixion* originally bore the legend "I am a Jew" in German, corresponding to the traditional inscription on the crucifix, "Jesus Christ, King of the Jews," which here appears both in Hebrew and in its Latin acronym. Chagall later painted over these words, deciding that they were too literal and too melodramatic an expression of his sufficiently obvious theme of Jewish suffering, not only in the 1930s but throughout history.[40] Clearly,

62

62. *White Crucifixion,* 1938
Oil on canvas, 60⅜ × 55 in.
The Art Institute of Chicago; Gift of
Alfred S. Alschuler

Chagall sought a symbol that would be as accessible as possible throughout the world, to serve as a plea for help. In his thinking, Christ was not "the son of God"; rather, he believed that "Christ is a poet," the "universal poet of Jewish suffering" and of the suffering of all peoples in despair.[41]

During the 1940s, as Chagall's prophetic visions of a holocaust became a nightmarish reality, his treatment of crucifixion-related themes multiplied. *The Crucified* is a haunting winter scene in which poor Russian Jews are shown nailed to crosses along the street of their village. In *The Martyr* a similar figure is shown bound to a stake. He is wrapped in a *tallis*-like garment and his rope bindings suggest the leather bindings of phylacteries. Behind him lies his village, erupting in flames. Out of the sky fall animals—a goat and a chicken—traditionally associated with sacrifice in ancient Jewish ritual. At the lower right a man recites the Kaddish, the Jewish prayer for the dead. The central figure carries more than a little suggestion of self-identification on the part of

63

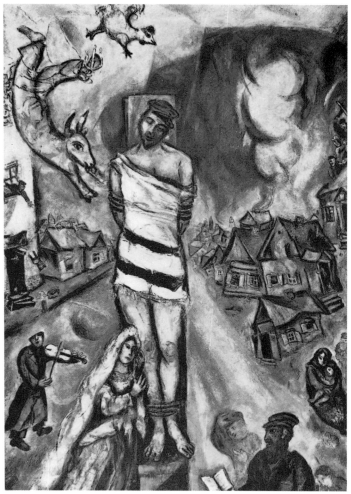

64

65

63. *The Crucified,* 1944
Gouache on paper, 24½ × 18⅝ in.
Vitya Vronsky Babin

64. *The Martyr,* 1940
Oil on canvas, 64¾ × 44⅞ in.
Estate of the artist

65. *Yellow Crucifixion,* 1943
Oil on canvas, 55⅛ × 39¾ in.
Musée National d'Art Moderne,
Centre Georges Pompidou, Paris

the artist, and it brings to mind Chagall's musing (in a c. 1944 poem he titled "To Bella") that "like Christ, I, too am crucified, fastened to my easel with nails."[42] The famous *Yellow Crucifixion* is a fascinating mixture of Old and New Testament imagery. The figure of Christ is shown wearing phylacteries and also radiating the halo of a Christian saint. An "angel of the annunciation" heralds not the birth of Christ but the gift of the Torah, the fundamental body of Jewish law and cultural doctrine, shown as an open scroll. There is a suggestion of the flight to Egypt by Joseph, Mary, and their child, but here the flight is from a *shtetl* in flames. At lower left is what seems to be a scene from the book of Jonah.

Of course, Chagall himself was in great peril after the Nazi invasion of France in 1940 and the establishment of the puppet Vichy government there. His escape from the Nazis offers yet another instance of his being miraculously rescued from disaster. In spite of the invasion of Poland and the declarations of war in 1939, Chagall felt no urgent need to abandon Europe. His sense of immediate danger was probably diminished by the fact that he and his family had finally been granted French citizenship in 1937. In the spring of 1940 he bought a house in the enchanting village

of Gordes, in Provence, where he would be far removed from the border with Germany.

The Chagalls arrived in Gordes shortly before the German invasion and the sudden collapse of the French government. Yet Chagall remained his usual insouciant self, seemingly oblivious to the danger. That winter the American consul general at Marseilles arrived in Gordes, together with the director of the Emergency Rescue Committee, to convey to Chagall an invitation from the Museum of Modern Art in New York to go to the United States. Chagall declined, still unimpressed by the danger. However, at the end of winter, when the Vichy government instituted strong anti-Semitic measures, the artist's daughter and son-in-law were stripped of their status as naturalized citizens. Chagall was persuaded, with difficulty, that the time had come to act. He and Bella moved to Marseilles, where departure could be more easily arranged.

Through the intervention of yet another guardian angel—a cabinet minister who happened to be a leading figure in the French Resistance—four passports were arranged. Yet difficulties still remained. Chagall and his wife were rounded up for interrogation by the French police, who routinely handed over foreign Jews to the German Gestapo. Hearing of this, the American consul general rushed to police headquarters and arranged for the release of the terrified couple. This incident ended all indecision. On May 7, 1941, Chagall and Bella crossed the Franco-Spanish border en route to Madrid. In the Spanish capital the Nazis arranged to have customs impound Chagall's packing cases, containing almost one thousand paintings and drawings. He found help through a curator at the Prado, who succeeded in having the cases released. The artist and his wife, delaying no longer, boarded a train for Lisbon, where they embarked by boat for New York, arriving on June 23. They were relieved to be safe but unhappy to have been forced into exile in this strange new land, so different and so far from France.

The Chagalls took up residence in a small apartment building at 4 East Seventy-fourth Street. Chagall did his best to establish a routine, but he never adapted comfortably to life in the United States. He never needed to learn much English, for he had no trouble finding Russian Jews on the streets of New York, with whom he could chat in Yiddish or Russian. His homesickness was eased also by his regular contacts with a large community of fellow artist-émigrés such as Ossip Zadkine, Jean Hélion, and Fernand Léger. Additional solace was afforded by his frequent trips to rural areas of Connecticut and New York.

One of the most important events of Chagall's seven years in America was the commission he received in 1942 from Léonide Massine of the National Ballet Theater to create sets and costumes 66 for a work entitled *Aleko,* based on music by Pyotr Tchaikovsky and a story by Aleksandr Pushkin. This was the first time Chagall had the opportunity to design for ballet, and it established a major new area in his art. Because of trade union difficulties, the National Ballet Theater was unable to open its autumn 1942 season in New York, so the entire troupe, along with the Chagalls, moved

66

66. *Aleko. Decor for Scene III: Wheatfield
on a Summer's Afternoon,* 1942
Gouache, watercolor, wash, brush, and pencil
on paper, 15¼ × 22½ in.
The Museum of Modern Art, New York;
Acquired through the Lillie P. Bliss Bequest

to Mexico City, where *Aleko* premiered in early September. This event was a great triumph for the company and for the artist, and the success of *Aleko* would lead to many other ballet commissions. The stay in Mexico was also visually stimulating for Chagall, who loved to travel and to discover "exotic" new sources. The influence of Mexican art, culture, and landscape remained evident in his work for some time after his return to New York.

In the late summer of 1944 Chagall was working at Cranberry Lake, in the Adirondack Mountains of New York State. There he and Bella heard the news of the liberation of France. But the artist's elation was to be brief, for shortly thereafter Bella became ill with a respiratory infection, from which she died on September 2. Chagall had lost his beloved muse, his support and inspiration through thirty-five years. This was the worst, perhaps the only, authentic personal tragedy he had ever known. Deeply grieved, he ceased working for nine months. When he resumed, in the spring of 1945, it was to create tributes to his departed wife.

67 *Around Her* depicts Bella weeping, leaning toward a scene of her native town presented to her by a floating acrobat. The artist appears at his easel at the lower left, his head inverted in a standard Chagall image of confusion, revery, or distress. At the upper right a bridal couple is embowered, as in so many of Chagall's paintings. At the upper left a bird-angel carries a lighted
68 candle, in memoriam. *Blue Concert* is a touching re-creation of
57 the composition in *Angel with Red Wings*. Bella is depicted with a dreamy gaze and the enigmatic calm of the Mona Lisa.

Chagall was eventually able to find comfort and solace in his work. The latter half of 1945 was occupied largely by a commission from the National Ballet Theater to create sets and costumes for Igor Stravinsky's *Firebird*. During the winter Chagall purchased a small timber cottage at High Falls, in northern New York State, where he created all his important works between 1946 and 1948. It was also during the latter half of 1945 or the beginning of 1946 that the artist established a liaison with a young woman named Virginia Haggard McNeil, the daughter of a minor Irish lord and wife of an impoverished painter. Obliged to find employment to support her young daughter, Virginia had become the housekeeper at Ida Chagall's apartment in New York City, where Chagall was living and painting. Their acquaintance soon blossomed into a relationship that was to last through the early years of Chagall's return to France in late 1948–49, and it resulted in the birth of a son, David McNeil.[43]

69 In Chagall's most important painting of 1947, *Self-Portrait with Wall Clock*, Virginia appears as a central figure—the woman with the ultramarine and azure face. She leans consolingly on the artist, rendered here as a sad-eyed goat painted in the reds of passion, flame, catastrophe. On the easel at the window is a canvas with a green Christ wearing the *tallis*-loincloth, embraced by the figure of Bella as a bride. In place of his golden halo, a golden cock crows the dawn. Another familiar Chagall symbol of time, the family living-room clock, flies overhead on winged blue hands. With the somber visage of the artist (still grieving for his wife), with his self-image as a Christ-like figure "fastened to my easel

67. *Around Her,* 1945
Oil on canvas, 51⅝ × 42⅞ in.
Musée National d'Art Moderne,
Centre Georges Pompidou, Paris

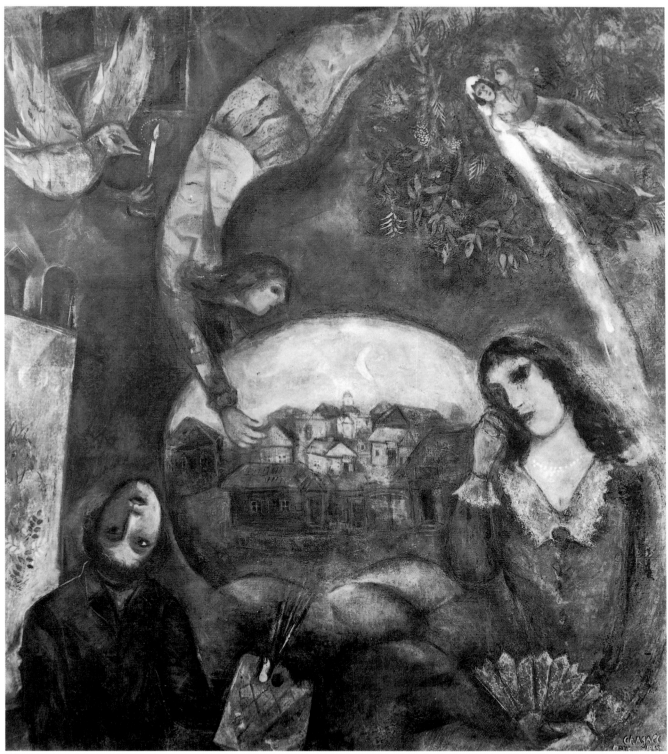

67

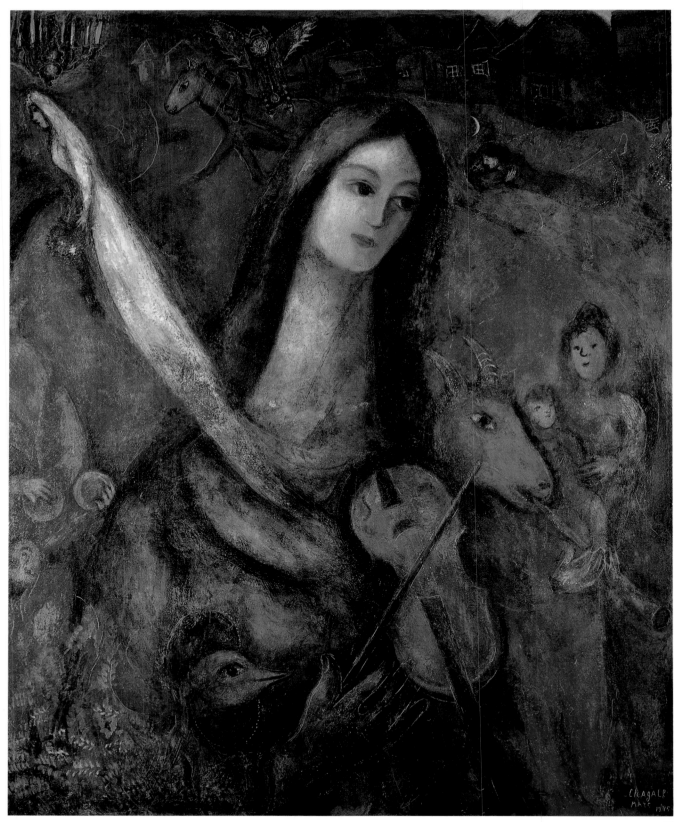

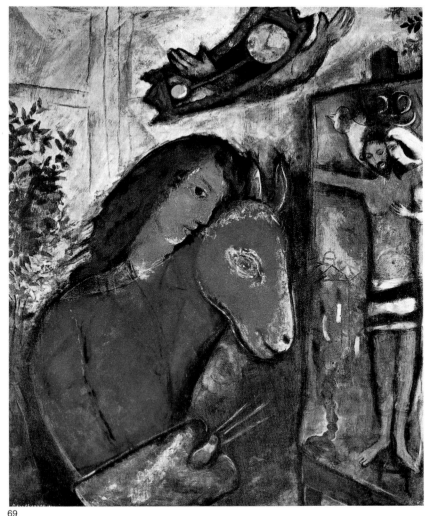

69

with nails," and with the guilty, conflict-ridden tension between the presence of Virginia and the memory of Bella, *Self-Portrait with Wall Clock* is a somewhat troubled work to be sure, but also one of Chagall's most fascinating and revealing compositions.

The spring of 1946 brought additional honors and recognition to Chagall, in the form of a major retrospective exhibition at the Museum of Modern Art in New York. This was his first important museum show since 1933, and it did much to enhance his fame around the world. The autumn of 1946 found Chagall back at High Falls working on a commission for a suite of thirteen colored lithographs to illustrate the *Arabian Nights*. This edition was published two years later in a portfolio with a text illustrated by thirteen additional lithographs in black and white. Since his illustrations for Vollard still awaited publication, this was Chagall's first illustrated book to have been published since the 1920s. The *Arabian Nights* illustrations were also his first colored lithographs, and they provided a basis for his enormous body of work in that medium during the years to come.

Chagall's principal creation of 1947 was *The Falling Angel*, one of the largest easel paintings of his career. He had been working

68. *Blue Concert,* 1945
Oil on canvas, 49½ × 40½ in.
Private collection

69. *Self-Portrait with Wall Clock,* 1947
Oil on canvas, 33⅞ × 27⅞ in.
Estate of the artist

95

70

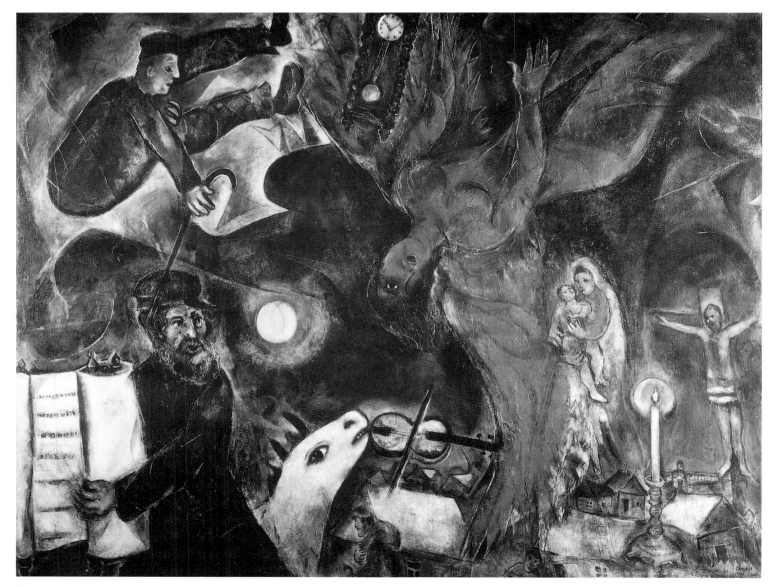

70

70. *The Falling Angel,* 1923/33/47
Oil on canvas, 57⅞ × 104⅜ in.
Offentliche Kunstsammlung, Kunstmuseum
Basel, Basel, Switzerland; Loan of Madame
Ida Chagall

on this composition since the early 1920s—prior versions had appeared in 1923 and 1933. This is a very dark, very opaque painting, in the mood of Chagall's work of the war years and in pronounced contrast to the bright bouquets and acrobats of the 1920s and '30s. Yet it is also clearly reminiscent of the 1933–36 image of Bella in *Angel with Red Wings*. Here the red angel descends as though stricken in midflight, dividing the composition in two. A figure of Bella as bride and as mother arises alongside. To the earlier versions of this work have been added the wartime images of catastrophe—the Jewish Christ, the winter *shtetls* in flames, the Jew fleeing with the Torah, the memorial candle. As with his summative murals for the Kamerny Theater of the early 1920s, Chagall used this large composition as a comprehensive presentation of his recent iconography. *The Falling Angel,* in a sense, closed another chapter in Chagall's career, but the images in it were to reappear again and again in his late work.

In the autumn of 1947 Chagall was honored with yet another retrospective, this time at the Musée National d'Art Moderne in Paris. He returned to Paris for the opening of this exhibition, which subsequently traveled throughout Europe. The artist had been dreaming of his return to France ever since his departure in 1941. He had gone back for a visit in the spring of 1946 but felt it was not yet time to resettle in a Europe destroyed by war and struggling to rebuild. However, by mid-1948 Chagall was ready to end his sojourn in America, and that summer he made preparations for a final return to France.

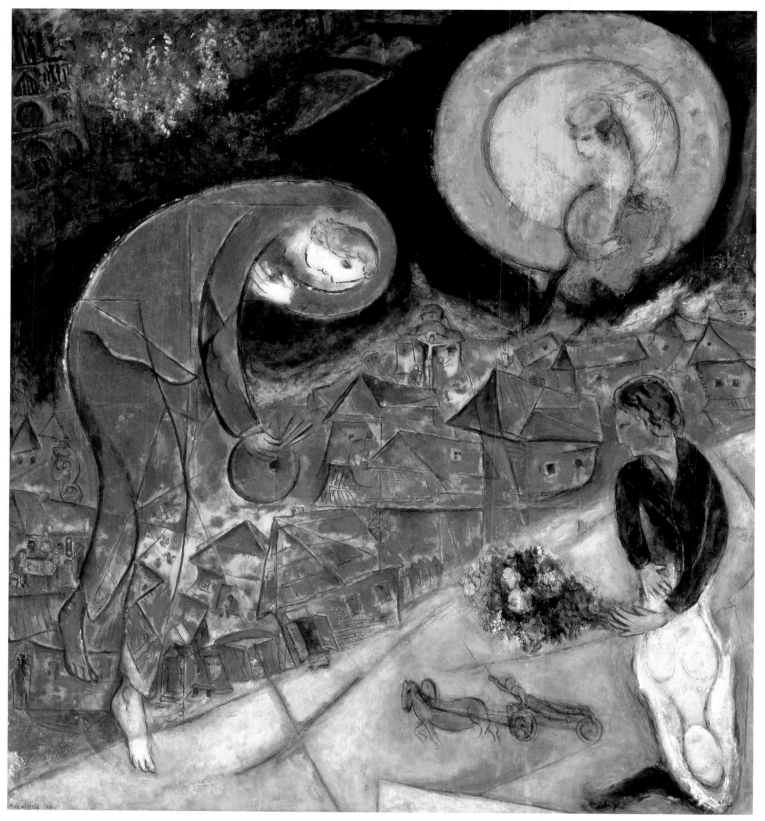

6 A Final Homecoming

When Chagall arrived in Paris in August 1948, he was received with an adulation greater than he had ever known. He was celebrated, along with Picasso and Matisse, as one of the great figures of the School of Paris. This recognition was reinforced at the Venice Biennale of that year, where Chagall's work was given its own room in the French pavilion and where he received the award in graphic art. Henceforth he was pursued by an endless stream of collectors, critics, publishers, dealers, and journalists.

The most interesting aspect of the following decade in Chagall's career was his decision to explore unfamiliar media. He had already achieved a high degree of diversification, but he had never worked in the plastic arts—sculpture and ceramics. Now, in his early sixties, Chagall ventured into these territories for the first time. His ceramic works of the 1950s are characterized by great charm and sensuousness, by simplicity, lightness, and childlike playfulness—the same qualities that characterize the vast number of lithographic poster prints he produced in the same years. The end of the war and his exile, the end of mourning for Bella, and his great acclaim all contributed to this lightening of tone. Contributing also was Chagall's 1950 move to Vence in southern France, where he bought a house overlooking the sea. He loved the light and color there, and it was to remain his principal home to the end of his life.

There is a marvelous grace of line featured in Chagall's many ceramic and sculptural compositions made during the 1950s. It may be relevant that at this point in his life he came to a particular appreciation of the music of Mozart,[44] for these works seem informed by a peculiarly Mozartian sense of grace and sensuous delicacy. They seem freed from the burdens of Chagall's memories and from the obligations of his profound loves—for Vitebsk, for his parents and relatives, for Bella. No nostalgia infuses these expressions in clay and stone. Working with these new materials must have been more like play, offering a kind of relaxation and a respite from the past. In his sculptures as well as in his lithographs of the same period, Chagall did not appear to seek the same level of difficulty, complexity, or density of emotional con-

71. *Red Roofs,* 1953
Oil on paper, mounted on canvas,
86⅝ × 83⅞ in.
Musée National d'Art Moderne,
Centre Georges Pompidou, Paris

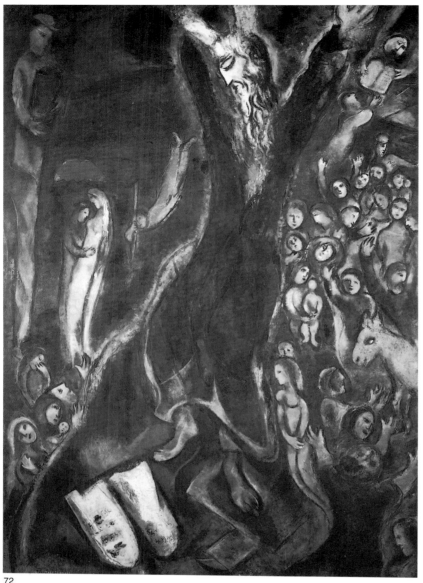

72

tent that is often found in his major paintings. Instead, there is a
simpler sense of delight and joy.

Throughout this time Chagall continued to paint prolifically in
gouache and oil. Possibly his most important painting of the
1950s, and certainly one of the finest of his career, is the large
71 *Red Roofs* of 1953. Once again, in this composition of diagonal
bands, Chagall used the large format as a compendium of his
iconography. Running through the central area of the picture is a
red band formed by a cubistic rendering of the houses and roof-
tops of Vitebsk. At the far left appears a tiny version of the fa-
miliar scene in the Chagall living room, with its now-famous wall
clock. Above the town, painted in the same red, floats the artist
with his palette, coiled in the most graceful arabesque. To the right
a figure carrying a Torah is framed against the concentric sun-
moon disks of Delaunay. At the lower right is a curious double
20 figure, recalling *Temptation (Adam and Eve)* of 1912, which is
formed by the conjunction of a younger Chagall and a ghostly

72. *Moses Breaking the Tablets of the Law,*
1956–57
Oil on paper, mounted on canvas,
89¾ × 57⅞ in.
Museum Ludwig, Cologne, West Germany

half-image of his bride, Bella. In his hand he holds a bouquet, ever Chagall's symbol of youthful love and joy. In the upper left corner of the painting, behind a curtain of springtime branches, appears Notre Dame, with the Seine flowing by. As in his *Self-Portrait with Seven Fingers*, the beloved image of Paris stands behind the painter.

93

While easel paintings, ceramics, sculpture, and lithography were essential components of Chagall's oeuvre in the 1950s, three other areas were to emerge as the most characteristic of this decade and were to prepare the most fertile ground for his late career. Those three were: his paintings of scenes from the Bible, his set designs for ballet, and most important of all, his designs for stained-glass windows.

In 1948, the year of Chagall's return to France, the nation of Israel was born as a Jewish homeland—an event promising freedom and deliverance for Jews throughout the world. Perhaps that event was a factor in Chagall's decision, in the early 1950s, to undertake a series of very large paintings of Old Testament scenes. In 1951 he made his second journey to the Holy Land, to attend the opening of a retrospective of his work at the Bezalel National Art Museum in Jerusalem; he also traveled to Haifa and Tel Aviv. As his first visit in 1931 had allowed him to discover "light and earth" in producing his Bible illustrations for Vollard, so this return visit fired him with a new enthusiasm that was doubtless another force behind the large biblical paintings.[45] A third factor was the announcement by the publisher Tériade of plans to produce an illustrated edition of the Bible with the 105 plates created by Chagall for Vollard in the 1930s. The rebirth of this dormant project (the edition was finally published in 1956) seems to have further stimulated the artist's interest in the Old Testament.

Monumental themes such as *Moses Receiving the Tablets of the Law*, *Moses Breaking the Tablets of the Law*, and *The Crossing of the Red Sea* began to appear repeatedly in Chagall's work at this time. These themes represented for him the possibility of a new kind of monumentality, a true monumentality. Previously, his large compositions had essentially been pastiches of his own repertory. Now, in these powerful, mythic images of the Old Testament, Chagall found the inspiration to create single, central figures in massive scale. His miscellanies in clay, stone, and bronze had already helped him escape his bondage to the past, but these biblical paintings carried far greater weight and importance. They were for Chagall the key to a new universality of communication, which fulfilled his need and his potential (given his worldwide fame) to speak to a greater audience. Henceforth it would be the monumental composition, rather than the smaller easel painting, that predominated in Chagall's art.

73
72

In 1952 Chagall met and married a woman of Russian-Jewish background named Valentine (Vava) Brodsky. A friend of Chagall's daughter, Ida, Vava was about twenty-five years younger than the artist. For the rest of his life, she was to serve as his muse and helpmate, organizing his daily affairs and assuming the place formerly occupied by Bella (and, more briefly, by Virginia McNeil) as the central female figure in Chagall's paintings.

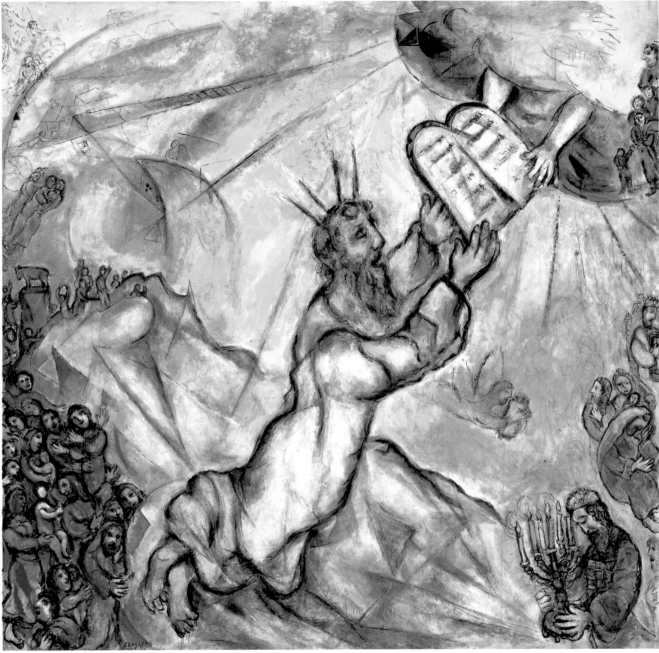

73

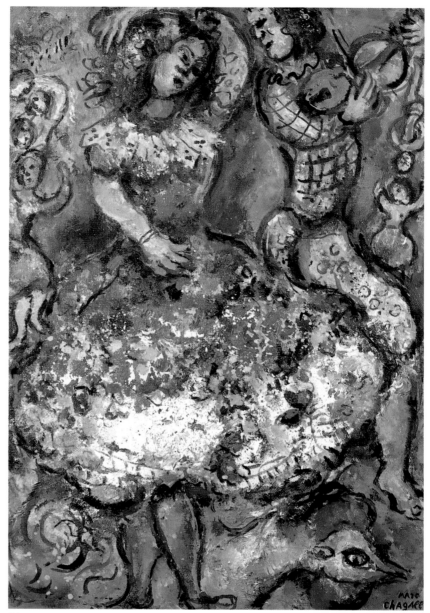

74

73. *Moses Receiving the Tablets of the Law,* 1956–57
Oil on canvas, 93¾ × 92⅛ in.
Musée National Message Biblique Marc Chagall, Nice, France

74. *The Dance to Happiness,* c. 1957
Oil on canvas, 57 × 38½ in.
Mrs. Hilde W. Gerst

In the latter 1950s Chagall's work grew ever larger, in the ongoing quest for greater monumentality that had begun with *The Falling Angel* in 1947. As the artist said, "That picture changed everything. I started to realize that studio paintings weren't everything, that, in fact, I had to get out of the studio. An artist just has to get out, not like Courbet, to pull down the Vendôme column, but to really work in depth."[46] Thus the paintings of his deliciously lyrical Paradise cycle from 1958–61 are of substantially greater dimensions than the large biblical paintings that preceded them. Yet even in his interpretation of the Expulsion from the Garden of Eden, Chagall's vision remains pastoral, scarcely less idyllic than the scene of contentment within Paradise. Again, Chagall's world, with the exception of his wartime allegories of holocaust, contains relatively little in the way of violence or evil.

70

75

76

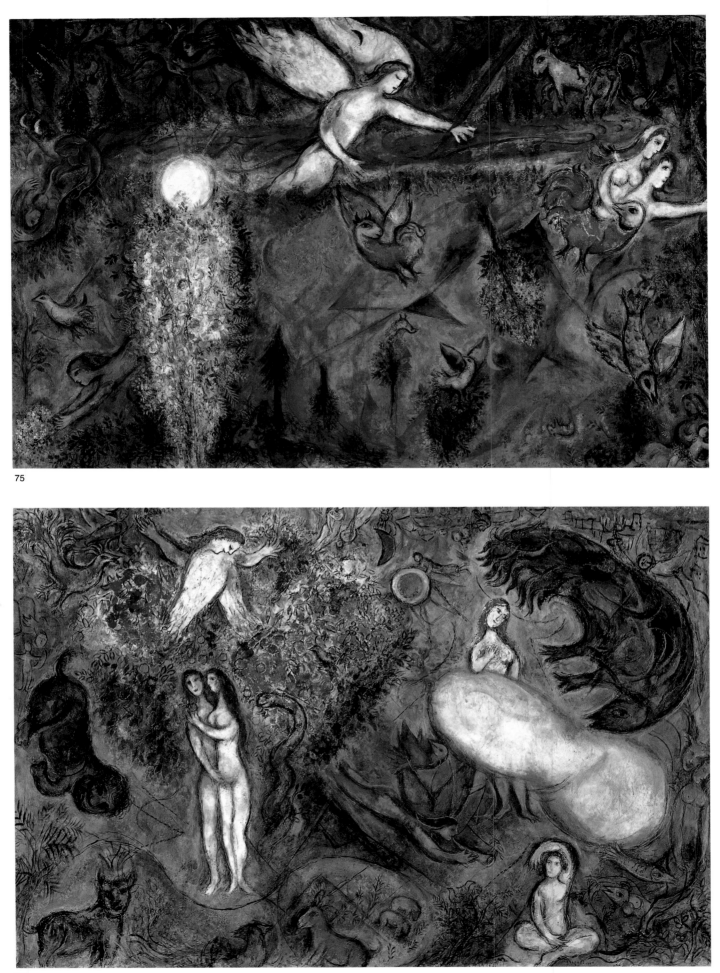

75

76

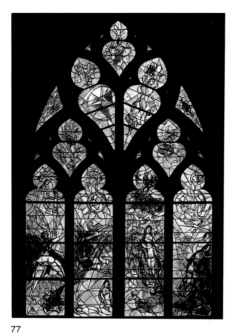

77

This impulse toward ever-greater monumentality in a pastoral mode was furthered when Chagall received, in 1958, a commission from the Paris Opéra to design sets and costumes for the ballet *Daphnis and Chloé*, with music by Maurice Ravel and choreography by Michel Fokine. The story is based on a pastoral romance written by the Greek poet Longus in the second or third century A.D. Chagall had executed a suite of color lithographs illustrating this same romance for the publisher Tériade in 1952. This preparatory experience, his own rather pastoral and amorous sensibilities, and his earlier staging of *Aleko* and *The Firebird* 66 made the *Daphnis and Chloé* production a harmonious one for Chagall, and it proved to be an enduring success.

However, it was neither in the pastoral mode nor in his familiar media of painting and graphics that Chagall's yearning for monumental expression was to find complete fulfillment. It was rather to be in religious themes expressed in still another medium he had never attempted prior to the 1950s—the medium of stained glass. Not only had Chagall never worked in glass, but the medium was one that had not proven terribly sympathetic to advanced artists of the twentieth century. The idea of designing windows first occurred to him in 1950, his most fertile year of new exploration and experimentation, shortly after he had moved to Vence. An unused chapel there came to his attention, and he began to conceive the idea of a cycle of biblical decorations for that specific setting.

The Vence chapel project was never realized in its original form, but it was in the process of thinking about its windows that Chagall began to contemplate seriously the techniques of creating stained glass. In 1952 he visited Chartres Cathedral specifically to study the Gothic windows there, and he became especially entranced by the medieval glassmakers' use of blue, a color so prominent in his own palette.

In retrospect, Chagall's large biblical paintings from the 1950s convey a sense that he was using them to prepare for something even grander. When, in 1956, he received his first commission for leaded-glass windows for the baptistry in the chapel of Notre-Dame-de-Toute-Grâce in Assy, France, that "something" was not yet realized. The chapel at Assy is a remarkable collaborative project that benefited from the contributions of some of the most distinguished artists of this century, among them, Henri Matisse, Georges Rouault, Georges Braque, Jacques Lipchitz, and Fernand Léger. Chagall's two rather small windows for Assy, completed and installed in 1957, are nothing more than the barest drawings of gossamer angels in grisaille on glass, in which the drawing is not even integrated in any special way with the lines formed by the lead joints. It is the most tentative sort of exploration, but this modest beginning was to open a new world for him.

As a result of this commission Chagall was asked by the chief architect for the restoration of the cathedral in Metz, France, to create a cycle of huge windows. By the spring of 1958 Chagall 77–79 had completed cartoons for two of these windows based on earlier biblical paintings, among them his *Moses Receiving the Tablets of the Law*. The translation of these designs into glass took him to

75. *Adam and Eve Expelled from Paradise,* c. 1958–61
Oil on canvas, 74⅞ × 111⅞ in.
Musée National Message Biblique Marc Chagall, Nice, France

76. *Paradise,* c. 1958–61
Oil on canvas, 72⅞ × 113 in.
Musée National Message Biblique Marc Chagall, Nice, France

77. *Creation of Adam and Eve, Paradise, Original Sin, Expulsion from Paradise,* 1963
Stained- and leaded-glass window,
139¾ × 35⅜ in. each panel
Metz Cathedral, Metz, France

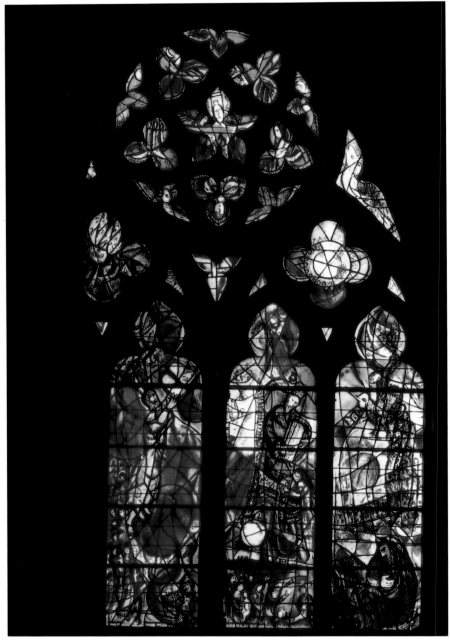

78

the famous Atelier Simon at Reims, France, run by Charles Marq
and Brigitte Simon Marq, heirs to a two-century family tradition
of crafting stained glass. It was through his collaboration with the
Marqs that Chagall became an artist in stained glass, learning
techniques and theories from them as they struggled to work out
the complex color variations of his designs. Of the earliest win-
dows completed for Metz, Chagall declared,"This is only an em-
bryo, but now I am beginning to sense all the possibilities."[47]

Others began to sense the possibilities also. When the first win-
dows destined for Metz were exhibited at Paris in 1959, the ar-
chitect of the new Hadassah–Hebrew University Medical Center
in Jerusalem saw them, and he was sufficiently impressed to invite

78. *Moses before the Tablets of the Law,
David and Jeremiah,* 1960
Stained- and leaded-glass window,
142¼ × 39⅜ in. each panel
Metz Cathedral, Metz, France

79. *Sacrifice of Abraham, Jacob
Fighting with Angel, Jacob's Dream,
Moses,* 1960
Stained- and leaded-glass window,
142¼ × 36⅛ in. each panel
Metz Cathedral, Metz, France

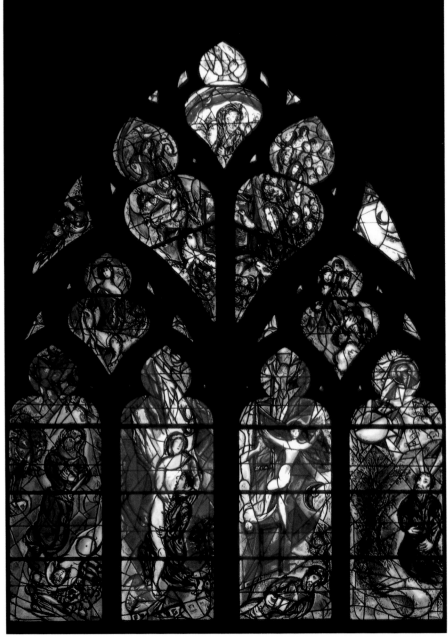

79

Chagall to create a cycle of twelve windows for the hospital, based on the theme of the twelve tribes of Israel. Each of the windows was to be approximately eleven feet high by eight feet wide, far larger than Chagall's few previous efforts in glass. Recognizing the immense personal and public significance of this project, he stopped work on the Metz windows in order to begin immediately on those for Jerusalem. A particular challenge he confronted was the requirement that human figures be avoided because of the strict orthodox Judaic proscription against the representation of people ("graven images"). Chagall proved equal to the challenge, dedicating himself through the remainder of 1959 and all of 1960 to this grand enterprise.

81, 82

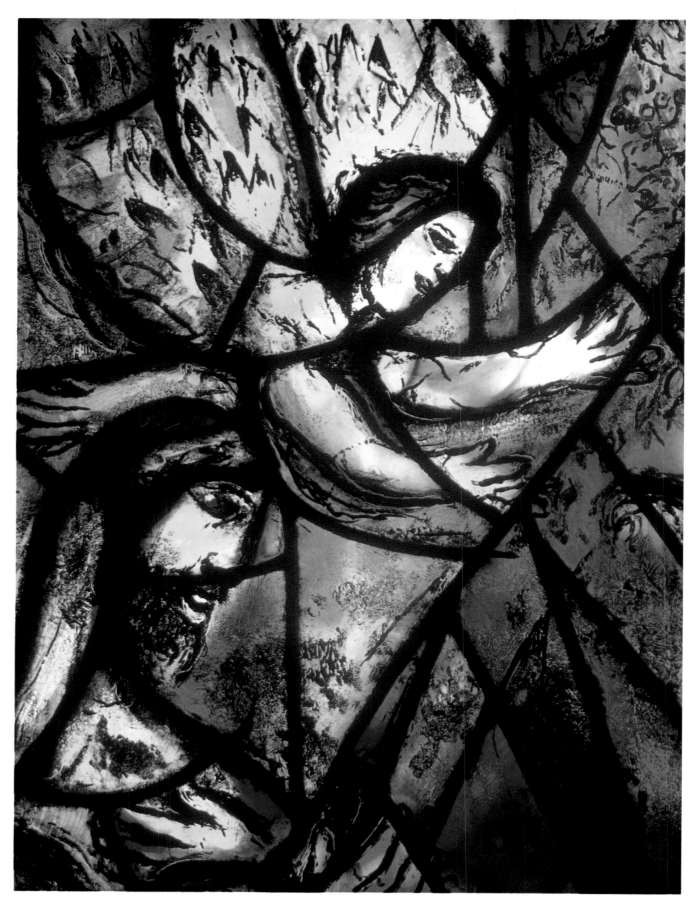

7 The Great Commissions

The unveiling of Chagall's *Jerusalem Windows* in Paris in June 1961 marked the beginning of a long and glorious final chapter in his career. Hundreds of thousands of people went to see these remarkable creations in Paris and then in New York later that year. By the time they were installed at the Hadassah–Hebrew University Medical Center Chapel in 1962, Chagall was established as perhaps the leading architectural decorator of his era and as unquestionably the most influential designer of stained-glass windows in the twentieth century. He played a singular role in revitalizing the art of the stained-glass window, and throughout the Western world there are countless religious sanctuaries constructed or reconstructed since 1962 that reflect his influence in their decoration. During the next two decades commissions for monumental works came to Chagall one after another: for the United Nations *Peace* window of 1964; for the ceiling of the Paris Opéra, installed the same year; for *The Sources of Music* and *The Triumph of Music* murals at the Metropolitan Opera in New York's Lincoln Center; for the four-sided ceramic mosaic *The Four Seasons* and the immense *America Windows*, both installed in Chicago in the 1970s; and for numerous other projects in Europe and America, including windows for cathedrals at Reims, France; Mainz, West Germany; Zurich; and Chichester, England.

There is a sense in which Chagall's entire life and career had been a preparation for this final triumph. His love for the poetry of the Old Testament, his fascination with the iconic and ecclesiastical arts in his native Russia, his familiarity with the Hasidic vision of an ecstatic union with the divine, and above all, his assimilation of the innovations of Robert Delaunay—all of these elements contributed to Chagall's unique success as a designer of monumental windows in stained glass. His friend and mentor Delaunay had dreamed of a "dynamic poetry of transparent color and light"[48]—a dream partly realized in his Simultaneous Window paintings of 1912–13, which are, in fact, conceived very much like overlapping sheets of colored glass. Chagall came to see that stained-glass windows might indeed be a form of painting in light. As he put it, "the light [in the stained glass] is the light of the sky, it is that light that gives the color!"[49]

81, 82

80

85

86

87

80. Detail of *Peace,* 1964
Stained- and leaded-glass window,
11 ft. 9 in. × 17 ft. 7⅞ in. overall
United Nations Secretariat Building, New York

Chagall's stained-glass windows turned out to be a dramatic realization of Delaunay's theories, enlivened by Chagall's own very personal sense of color, line, and image. His biblical paintings of the mid-1950s, such as *Moses Receiving the Tablets of the Law,* may be viewed as an anticipation of his work in stained glass (see, for example, his later windows for the cathedral of Metz). The lines of radiant energy that animate these explosive, ecstatic visions are the same sort of prismatic lines found in Delaunay's Simultaneous Windows and in much of Chagall's important early work in Paris. They are also closely related to the "lines of force" in paintings by Delaunay's Cubist predecessors and Futurist contemporaries. Curiously, these lines do not appear in Chagall's preliminary sketches or studies for his windows. He came to rely on his collaborators, the Marqs, to design the glass fragments and the lead came so that, in the final work, the seamlines fill the same role as the lines in his paintings, creating facets of light and a feeling of its radiant force.

The *Jerusalem Windows* are a mixture of Chagall's personal imagery with images from ancient Judeo-Roman mosaics. The

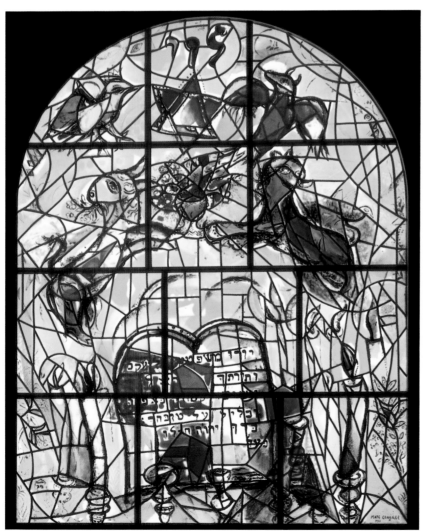

81

81. *The Tribe of Levi,* 1960–61
Stained- and leaded-glass window,
133⅛ × 98⅞ in.
Synagogue of the Medical Center,
Hadassah- Hebrew University, Jerusalem

82. *The Tribe of Issachar,* 1960
Stained- and leaded-glass window,
133⅛ × 98⅞ in.
Synagogue of the Medical Center,
Hadassah- Hebrew University, Jerusalem

result is a rich blend of drama and whimsy, sentiment and spirituality. Each window bears in Hebrew characters the name of one of the twelve tribes of Israel. The distinctive color compositions translate successfully into pigmented glass, to a degree that even its creators may not have anticipated. One of the first commissions to be stimulated by the acclaim for this project was for a window at the United Nations Secretariat Building in New York, a window dedicated to the memory of Dag Hammarskjöld, formerly the United Nations secretary general, who had died in 1961. For this *Peace* window, presented as a gift from the artist as well as from the United Nations staff, Chagall created a free, lyrical design, taking for his theme the prophecies of Isaiah regarding the future harmony of the world. Although the composition lacks some of the force and coherence of the windows at Jerusalem and Metz, it served, in its prominent location, to increase Chagall's fame.

On completing the *Jerusalem Windows,* Chagall had also returned to his work for the Metz Cathedral. The cycles of windows he created there, which were completed by 1968, are remarkable

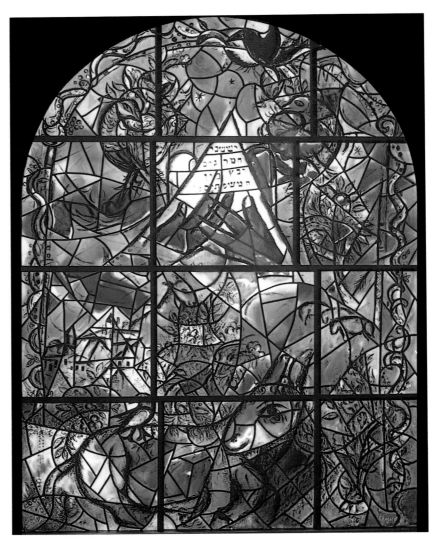

both for the expressive power of the biblical themes (such as Jacob wrestling with the angel and Moses before the burning bush) and for the astonishing delicacy of the windows devoted to purely floral designs. Stained glass—so resistant to the artist's personality and individual sensibility, so much less fluid and tractable than oil paint—was an unlikely vehicle for Chagall. Yet he used it in these floral windows to communicate his feelings of passionate love and lighthearted joy. The Metz windows are perhaps Chagall's greatest achievement in his new medium, and rarely in the entire history of this art had its potential to express exultant pleasure in nature been so exuberantly realized.

In 1963 Chagall was commissioned to create new ceiling decorations at the refurbished Paris Opéra (designed by architect Charles Garnier about a century before). The idea of a new ceiling for the immense opera house supposedly occurred to André Malraux, then minister of culture in France and a friend and champion of Chagall, at a 1960 performance of *Daphnis and Chloé* with the Chagall sets. Malraux immediately proposed the notion to the artist, and in 1963 the commission became fact. Despite Chagall's forty-year background of working in the theater, despite the unique appropriateness of his graceful floating figures to a neo-Baroque ceiling, and despite his international acclaim as an architectural decorator on a grand scale, this project engendered the most intense opposition. There were those who objected to any tampering with the original decoration of Garnier's century-old building. There were even more who challenged the idea of such an important project being given to a "foreigner."[50]

Nonetheless, the project went forward, and the seventy-six-year-old artist threw all his still-prodigious energy into the daunting task of creating the twelve canvas panels that cover the thirty-foot-wide central dome. After much experimentation, Chagall settled on the scheme of dividing the composition into five sections, each ruled by a different color and each paying homage to two composers known for their work in the theater. The blue section offers tribute to Modest Mussorgsky and Wolfgang Amadeus Mozart, the green to Richard Wagner and Hector Berlioz, the off-white to Jean-Philippe Rameau and Claude Debussy, the red to Maurice Ravel and Igor Stravinsky, and the yellow to Pyotr Tchaikovsky and Adolphe Adam. This traditional alternation of hot and cool tones creates the sense of a circular design scheme that gives the composition its unity and integrity. The composers are cited by name and represented by characters from their principal operas or ballets, such as *Don Giovanni, Boris Godunov,* and *Swan Lake.* Naturally, Chagall's personal imagery of animals and scenes from Vitebsk and Paris pervades the whole. The entire work is conceived almost as a huge ballet, and among the soaring, dancing figures there even appears that of Chagall, who "wickedly depicted himself partnered by Malraux."[51] Although the unveiling of the ceiling in 1964 was greeted by much hostile criticism, favorable responses have dominated.

After the consuming projects of 1963–64, Chagall returned for a time to his series of biblical illustrations begun in the 1950s. Known as The Biblical Message, this series, completed in 1967,

83. *The Prophet Elijah,* 1970
Stone mosaic with colored-glass pastes,
23 ft. 5½ in. × 18 ft. 8⅜ in.
Musée National Message Biblique Marc Chagall, Nice, France

84. *Entrance Tapestry,* 1971
Wool, 89 × 9 15⁄16 in.
Musée National Message Biblique Marc Chagall, Nice, France

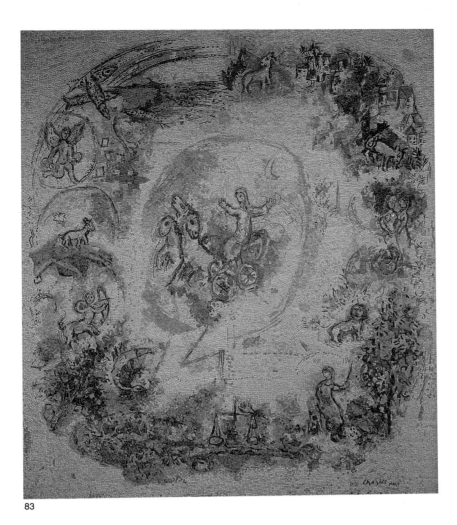

83

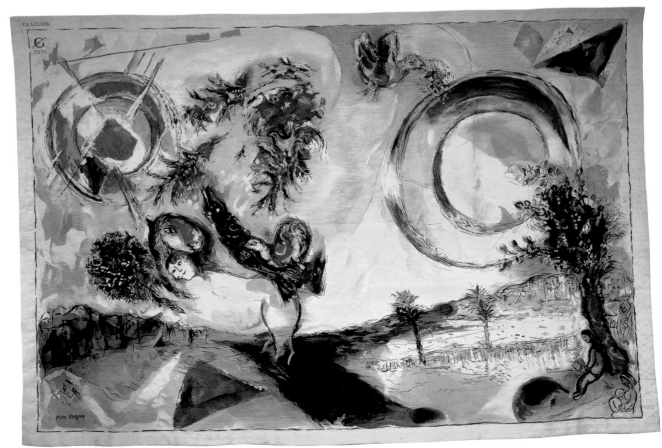

84

consists of thirty-seven gouaches, seventeen oil paintings, and three sculptures. Chagall offered this group of works as a gift to France. Malraux not only arranged for its acceptance, he even managed to have this body of work exhibited at the Louvre, an honor never before accorded a living artist. In 1969 The Biblical Message was installed at a museum in Nice built especially to house it, known as the Musée National Message Biblique Marc Chagall. The museum's collection also includes Chagall's biblical illustrations for Vollard, many lithographs of biblical scenes, and several monumental works donated during the 1970s, such as a stone mosaic depicting *The Prophet Elijah* and the tapestry woven in 1971 for the entrance to the museum, which displays a vast Judean landscape under two blazing suns.

In 1967 Chagall completed, in addition to his Biblical Message, one of his most important commissions in North America, the murals in the New York Metropolitan Opera titled *The Sources of Music* and *The Triumph of Music*. These immense canvas panels hang in the front windows above the entrance lobby. They are framed by one-half-inch bronze bars, which reinforce the sense of their separation from the walls. Situated at the far end of the rather austere white masses of Lincoln Center Plaza (designed by noted architect Wallace K. Harrison), the Chagall paintings provide welcome notes of color and warmth, although the installation makes them difficult to see in detail. One interesting feature of this installation, given Chagall's experience with stained glass, is the way the murals are seen through the segmented windows, a juxtaposition that gives the impression, from a distance, that these might be works in stained glass. In reference to the project, Chagall said, "You cannot resist the severe masses of modern American architecture with something in the severe manner of Mondrian or Léger. You have to do it with the movement of lines and colors."[52] Thus the paintings are conceived as dynamic arabesques of color. And yet, somewhat ironically, the grids of the windows before them are very much Mondrian-like, giving Chagall's murals a sense of precise geometry when viewed from outside.

As in his ceiling for the Paris Opéra, Chagall treated the Metropolitan Opera murals as a group homage to the great musicians and operatic composers of the past. In order to answer the inevitable queries about the symbolism of these works, the artist provided helpful legends, so the murals may be deciphered as an allegory.[53] Two immense figures dominate *The Sources of Music*, a composition primarily in yellow, with fluid accents in green, red, and blue. Standing at the center is a double figure holding a lyre, simultaneously representing both Orpheus and King David. Beneath this figure soars the even larger form of "The Angel Mozart." Around these central images swirl the smaller forms of Beethoven, Bach, and Wagner, plus groups of figures intended to represent Beethoven's opera *Fidelio*, an homage to Verdi, and Mozart's *Magic Flute*. Prior to receiving the commission for these murals Chagall had done for the Metropolitan Opera a successful production of *The Magic Flute*, an opera of childlike magic and delight and one eminently sympathetic to Chagall's own sense of fantasy. It was at about this time that Chagall made the declara-

83, 84

85

85. *The Sources of Music*, 1967
Oil on canvas, 36 × 30 ft.
Metropolitan Opera, Lincoln Center, New York

86. *The Triumph of Music*, 1967
Oil on canvas, 36 × 30 ft.
Metropolitan Opera, Lincoln Center, New York

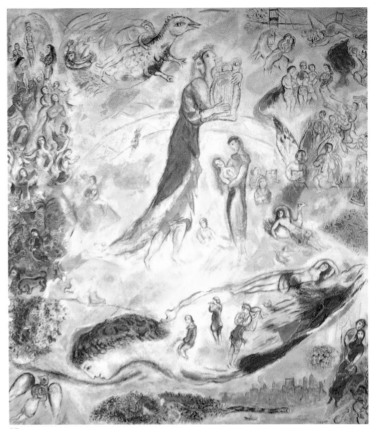

85

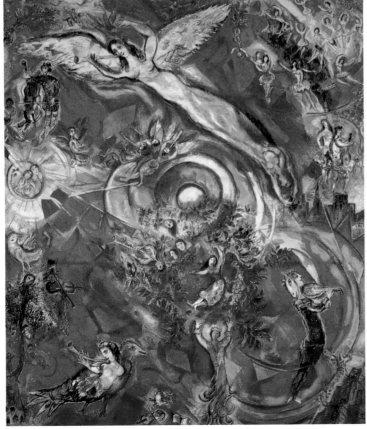

86

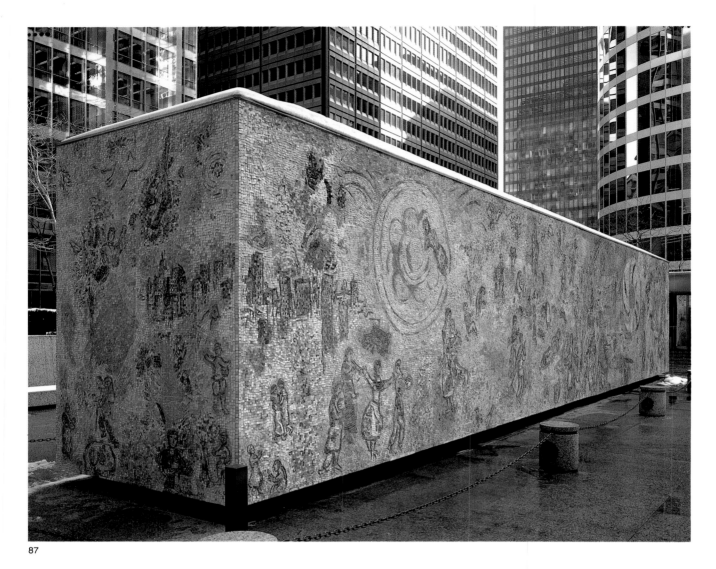

87

88

tion, "I believe in the truth of the Bible, as I believe in the truth of Mozart."[54] Chagall supposedly had certain misgivings about accepting the mural commission, but he agreed, in part, because he viewed it as an opportunity to pay tribute to the greatness of Mozart.[55]

The companion to *The Sources of Music,* titled *The Triumph of Music,* is a composition in red, with swirling notes of blue, green, and yellow. It contains, according to its legend, thirteen principal elements: 1. The Song of the People; 2. The Musician; 3. The Singer; 4. The Ballet; 5. Homage to American music; 6. *The Firebird;* 7. Homage to French music; 8. To Rudi Bing (then the general manager of the Metropolitan Opera); 9. Russian music; 10–11. Chagall and his wife; 12–13. New York buildings. It was in these murals that Chagall portrayed, for the first time, images of New York and the New World.

Among the other cities of the New World none has received Chagall more warmly or with more reverence than Chicago. He received invitations to participate in humanities conferences at the University of Chicago in 1947 and 1958, both of which he attended; and many of his major collectors have been from Chicago. Out of this ongoing relationship emerged the commissions for two of the most monumental and important works of Chagall's late career—*The Four Seasons* and *The America Windows. The Four Seasons* is a huge ceramic mosaic commissioned by the First National Bank of Chicago in 1972. The seventy-foot-long concrete parallelepiped is placed in the large open plaza of the bank building, surrounded by the gleaming glass towers of the Chicago business district. On the four sides of this concrete box are mounted four mosaic compositions; following an ancient tradition of art, each treats one of the four seasons of the year. As in so many of Chagall's large works, the compositions comprise images familiar in every period of his mature art. Possibly the strongest of these mosaics is that on the east side, suggesting a scene of summer in brilliant, almost Impressionist colors dominated by yellow tones, harmonized with glistening tiles of blue, red, and orange. A coastline, water, and flowers shimmer beneath the pyrotechnic pinwheel of an enormous, festive, exhilarating sun.

The America Windows is a three-panel, stained-glass work installed at the Art Institute of Chicago in 1979. Each panel appears to have been conceived as an independent composition, for there are motifs cut by the inside edges of the outside panels that do not reappear in the central panel. As in *The Four Seasons,* many of Chagall's traditional images recur here, but there are some surprising new additions as well, images that had never before appeared in his art. In the upper left corner of the left panel Chagall has introduced two musical staffs with a few notes placed on them. This "music" relates to the trumpeting of an angel (Gabriel?) in the adjacent glass segment to the right and to the cello immediately below. The staff lines and notes relate also to the underlying structure of the windows—a structure in itself highly musical. The windows are arranged in three horizontal registers, each divided by vertical bars into a syncopated pattern. Upon this rhythmic staff structure Chagall composed his "notation" of im-

86

87

88

87, 88. *The Four Seasons,* 1974
Ceramic mosaic, 70 × 14 × 10 ft.
First National Bank of Chicago Plaza

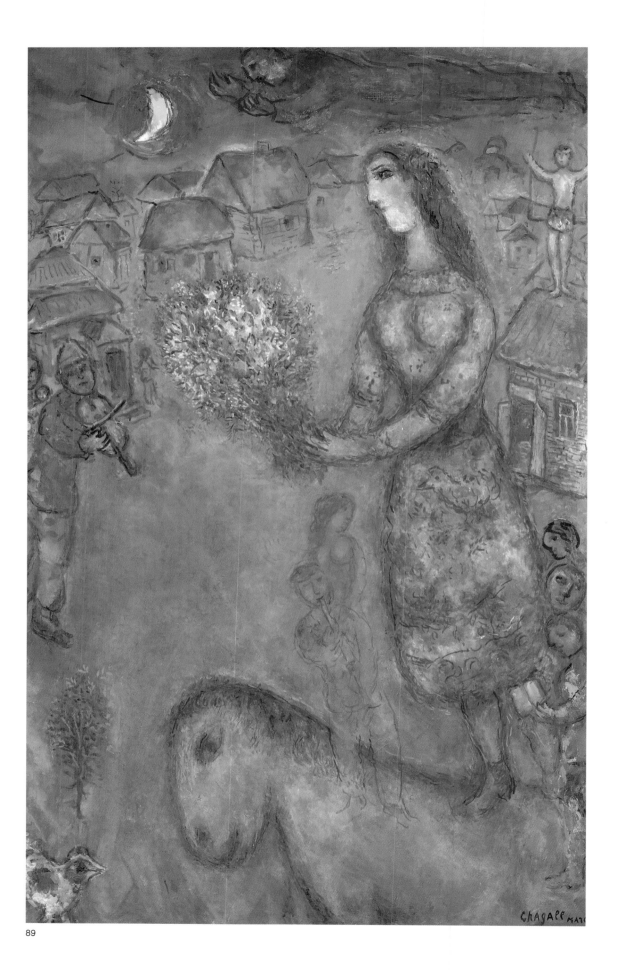

89

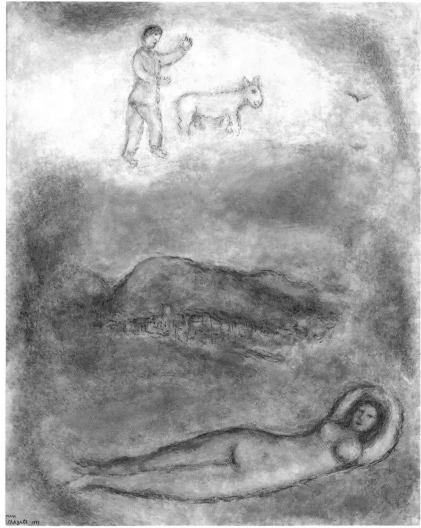

90

89. *Fiancée with Bouquet*, 1977
Oil on canvas, 51¼ × 31⅞ in.
Courtesy Pierre Matisse Gallery, New York

90. *Rest*, 1975
Oil on canvas, 47 × 36¼ in.
Courtesy Pierre Matisse Gallery, New York

91. *Isaac and Rebecca at the Well*, 1980
Oil on wood, 37⅛ × 94 in.
Musée National Message Biblique Marc
Chagall, Nice, France

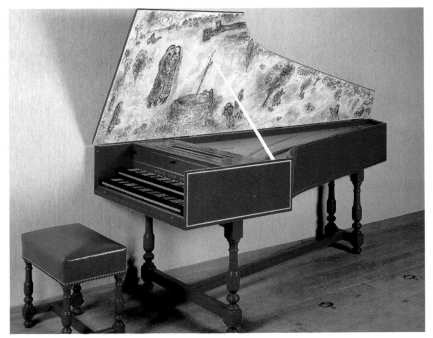

91

ages and colors. Here are the familiar chickens, doves, and angels but here also appear fresher images: a menorah; a huge seder plate, symbolic of the Passover rituals that Chagall had so loved in his childhood, which here takes the place of the giant suns so often found in his works. In the central panel he used, for the first time, the Statue of Liberty to give a specifically American identity to the windows named for this country.

The unprecedented "musicality" of *The America Windows* doubtless stems, in part, from Chagall's work on the Paris Opéra ceiling and the Metropolitan Opera murals. But it must also relate to that near-religious reverence for the music of Mozart to which he came relatively late in life and also to the admiration for the art of Paul Klee that he developed at about the same time.[56] There is another rather charming musical connection in one of Chagall's final contributions to his Musée National Message Biblique at Nice—the harpsichord whose cover he painted, after the manner of the decorated harpsichords of the seventeenth and early eighteenth centuries. The subject of this delightful work is the story of Isaac and Rebecca at the Well, but as usual, the background scenery and the supporting cast derive from the artist's memories of Vitebsk.

91

During his final years Chagall wound down his stained-glass work and public commissions, completing his last window projects for Mainz and Le Saillant, France, in the early 1980s. As his health slowly failed he traveled less and less, and he was unable to attend the opening of the major retrospective of his work at the Philadelphia Museum of Art in the spring of 1985, the first such absence in his life. But to the very end of his days he continued painting his romantic reveries of love and joy. He clung to the creed that might serve as an epitaph: "I ask nothing from life: I work like a cobbler, I love my wife, I am at peace."[57] He died on March 28, 1985, aged ninety-seven, in his beloved adopted homeland. Few lives are so long. Fewer lives are crowned with such glory. Fewer still are those who leave to their fellow beings such a rich vision of life's possibilities.

NOTES

1. Marc Chagall, *My Life,* trans. Elisabeth Abbott (1922; New York: Orion Press, 1960), pp. 35, 93.

2. A volume of Chagall's verse was published under the title *Poèmes, 1909–1972* (Geneva: Cramer, 1975).

3. Chagall, in Charles Sorlier, ed., *Chagall by Chagall,* trans. John Shepley (New York: Harry N. Abrams, 1979), p. 146.

4. From Chagall's preface to the catalog of the Musée National Message Biblique Marc Chagall, Nice; quoted in Pierre Provoyeur, *Marc Chagall: Biblical Interpretations,* trans. Charles Frankel (New York: Alpine Fine Arts Collection, 1983), pp. 11–12.

5. Chagall, *My Life,* p. 19.

6. Ibid., p. 54.

7. Jean-Paul Crespelle, *Chagall,* trans. Benita Eisler (New York: Coward-McCann, 1970), p. 144.

8. My principal sources for information on Chagall's early life and career have been *My Life* and Franz Meyer's comprehensive critical biography *Marc Chagall,* trans. Robert Allen (New York: Harry N. Abrams, 1964). Meyer, as the second husband of Chagall's daughter, Ida, was privy to many details about the artist's life that were unavailable to earlier writers.

9. Chagall, *My Life,* p. 39.

10. Ibid., p. 56.

11. Ibid., p. 65.

12. Ibid., p. 59.

13. While in Pen's studio Chagall made some hazy, rather Impressionist charcoal drawings that echo the style of the nineteenth-century Dutch-Jewish painter Jozef Israëls. Meyer claims to discern in these early drawings the influence of the Russian academician V. A. Serov (*Chagall,* p. 45).

14. Ibid., pp. 14, 591–92.

15. Chagall, *My Life,* pp. 61–62.

16. Chagall, in *Marc Chagall* (Paris: Musée des Arts Décoratifs, 1959), p. 128.

17. It is interesting to recall in this context Paul Klee's 1922 dictum, "pathos is expressed in art as a motor impulse off the vertical, or as denial or disruption of the vertical." *The Thinking Eye: The Notebooks of Paul Klee, Volume I,* ed. J. Spiller, trans. Ralph Manheim (New York: George Wittenborn, 1964), p. 191.

18. Chagall, *My Life,* p. 74.

19. In "Quelques Impressions sur la peinture française," a lecture delivered at Mount Holyoke College, August 1943; published in *Renaissance: Revue trimestrielle de l'Ecole des Hautes Etudes de New York* 2–3 (New York) (1944–45): 46.

20. Ibid.

21. See Jacques Lassaigne, *Chagall* (Paris: Editions Maeght, 1957), pp. 20ff.; see also Lionello Venturi, *Marc Chagall* (Geneva: Skira, 1956), p. 20.

22. Chagall, *My Life,* p. 106.

23. Some general discussions of the vogue for "simultaneity" are provided in G. Vriesen and M. Imdahl, *Robert Delaunay: Light and Color* (New York: Harry N. Abrams, 1968), pp. 60, 76–83; and Roger Shattuck, *The Banquet Years* (New York: Vintage Books, 1968), pp. 279–87, 296, 345–51.

24. See his essay "On Light" (1912), reprinted in Vriesen and Imdahl, *Delaunay,* pp. 6–9.

25. Meyer, *Chagall,* p. 170.

26. See, for example, Chagall's anecdote concerning a visit paid him in Paris by the Marxist journalist Anatoly Lunacharsky, later to be People's Commissar for Education and Culture in the Soviet Union. In answer to Lunacharsky's query about the enigma of the green cows, Chagall retorted, "Let Marx, if he's so wise, come to life and explain it to you." Chagall, *My Life,* pp. 138, 139.

27. Apollinaire, in Meyer, *Chagall,* p. 146.

28. Nell Walden and Lothar Schreyer, *Der Sturm* (Baden-Baden, West Germany: W. Klein, 1954), p. 17.

29. Chagall, *My Life,* p. 119.

30. Ibid., p. 120.

31. There is a curious inversion here, for the *lulav* is supposed to be held in the right hand and the *esrog* in the left. This is another of Chagall's inexplicable transpositions of conventional reality.

32. Chagall, in Michael Ayrton, *Marc Chagall: Sein Leben und Werk* (Berlin: Safari-Kunstreihe, 1958), p. 14.

33. Chagall, *My Life,* p. 172.

34. Raissa Maritain, *Chagall ou l'orage enchanté* (Geneva: Editions des Trois Collines, 1948), p. 189.

35. Crespelle, *Chagall,* p. 159.

36. Meyer, *Chagall,* p. 322.

37. Chagall, in Provoyeur, *Chagall: Biblical Interpretations,* p. 30.

38. A 1930 version of this painting is reproduced in Meyer, *Chagall,* p. 389. The earlier version does not include the lovers reclining on the river bank, and it strikes a less wistful, less melancholy note.

39. Ibid., p. 90; Lassaigne, *Chagall,* p. 20.

40. Meyer, *Chagall,* p. 414.

41. Ibid., p. 16.

42. Chagall, *Poèmes, 1909–1972,* p. 36.

43. This information comes principally from Crespelle, *Chagall,* pp. 236–38, and Sydney Alexander, *Marc Chagall: An Intimate Biography* (New York: Paragon House, 1988), pp. 481ff. No mention of Chagall's relationship with Virginia McNeil appears in Meyer's otherwise comprehensive study nor in most other writings on Chagall. Chagall openly acknowledged paternity of his son, David. A photo of the young David with his father in his studio appears in Meyer (*Chagall,* p. 44), but the boy is not identified. See also Virginia Haggard, *My Life with Chagall* (New York: Donald Fine, 1986).

44. Meyer, *Chagall,* p. 494.

45. Ibid., p. 550.

46. Chagall, in Crespelle, *Chagall,* p. 263.

47. Chagall, in Jean Leymarie, *The Jerusalem Windows,* trans. Elaine Desautels (New York: George Braziller, 1975), p. xi.

48. Delaunay, in Vriesen and Imdahl, *Delaunay,* p. 42.

49. Chagall, in Sorlier, ed., *Chagall by Chagall,* p. 212.

50. This had also been the case in the 1920s when Chagall had been commissioned by Vollard to illustrate the *Fables* of La Fontaine. See also Crespelle, *Chagall,* p. 268. For a general discussion of the ceiling, see Jacques Lassaigne, *Marc Chagall: The Ceiling of the Paris Opéra,* trans. Brenda Gilchrist (New York: Praeger, 1966).

51. Crespelle, *Chagall,* p. 268.

52. Chagall, in Roy McMullen, *The World of Marc Chagall* (London: Aldus Books, 1968), p. 238.

53. See Emily Genauer, *Chagall at the "Met"* (New York: Metropolitan Opera Association; distributed by Tudor Publishing, 1971).

54. Chagall, in Crespelle, *Chagall,* p. 270.

55. Genauer, *Chagall at the "Met,"* p. 40.

56. Meyer, *Chagall,* pp. 18, 591. Klee (a gifted musician whose most-venerated god, not coincidentally, was Mozart) often employed a distinctly musical approach to the composition of visual art, using staff lines to provide the basic structure upon which he set individual images and colors in the manner of musical notes. See Andrew Kagan, *Paul Klee: Art and Music* (Ithaca, N.Y., and London: Cornell University Press, 1983).

57. Chagall, in Crespelle, *Chagall,* p. 273.

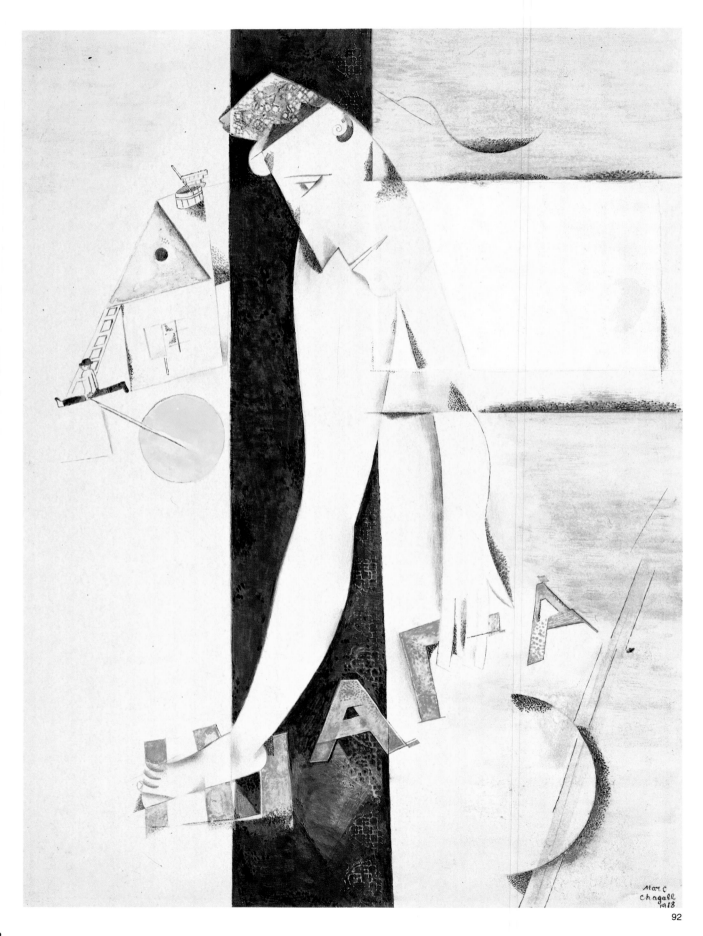

Artist's Statements

Undoubtedly my early trends were a little strange to the French. And I looked at them with so much love! It was painful.

But my art, I thought, is perhaps a wild art, a blazing quicksilver, a blue soul flashing on my canvases.

And I thought: Down with naturalism, impressionism and realistic cubism!

They make me sad and they cramp me.

All questions—volume, perspective, Cézanne, African sculpture—are brought on the carpet.

Where are we going? What is this era that sings hymns to technical art, that makes a god of formalism? . . .

Don't call me temperamental! On the contrary, I'm a realist. I love the earth. . . .

> From Marc Chagall, *My Life,* trans. Elisabeth Abbott (1922; New York: Orion Press, 1960), p. 110.

Art seems to me to be a state of the soul. . . .

Only the upright heart that has its own logic and its own reason is free.

> Ibid., p. 115.

It is a mistake for people to be scared by the word "mystical," to give it too much of a religious overtone. We must strip this term of its old-fashioned, musty appearance; and take it in its pure form, high and intact. Mystical! . . . How many times was this word thrown in my face, like the times when I used to be blamed for being "literary!" But without mysticism, would there be a single great painting, a single great poem, or even a single large social movement? Doesn't each organism, individual or social, wither away and die in the absence of a mystical force, of feeling, of reason?

> From "Quelques Impressions sur la peinture française," a lecture delivered at Mount Holyoke College, August 1943; published in *Renaissance: Revue trimestrielle de l'Ecole des Hautes Etudes de New York* 2–3 (New York) (1944–45): 45–57.

What has disturbed me in art since the time of the impressionists has often been the imperfection of the artistic language, a language

92. *Chagall,* 1918
Gouache on paper, 18¼ × 13⅜ in.
Musée National d'Art Moderne,
Centre Georges Pompidou, Paris

that is often approximate. How else can we explain the continuous shifting of art toward new styles and new content? Man is looking for something new; he must rediscover the originality of his own language—the language of our primitive ancestors, of those men who, when they spoke, spoke only their truth. The human species, however, is trying to rediscover that language without recourse to stylistic imitation.

From "The Artist," a lecture delivered at the University of Chicago, 1947; published in *The Work of the Mind* (Chicago: University of Chicago Press, 1947), pp. 21–38.

One cannot make a picture *with* symbols. . . . If a work of art is absolutely authentic, it naturally contains something symbolic, as in Klee, Grünewald, Mozart. One must not start out with the symbol, but *reach* the symbol. Symbolism is inevitable. . . . My symbolic poetry is unexpected, oriental, situated between China and Europe—but it is not always necessary to stress its symbolism.

C. 1962; quoted in Franz Meyer, *Marc Chagall*, trans. Robert Allen (New York: Harry N. Abrams, 1964), p. 14.

Impressionism opened wide a window before us. A rainbow started to shine, to radiate across the sky. But as the world adorned itself with different, more intense colors, it seemed to me that it was becoming narrower in a more general sense; that Courbet's naturalist world had in turn become narrower than the world Delacroix had introduced, and that Delacroix's world had become more confined and declamatory than David's and Ingres' Neoclassical world. . . .

After impressionism came cubism, which propelled us into the geometric maze of reality in the same way that abstraction has recently led us into the world of atoms and matter. We are beginning to grasp the degree and the measure of this continuous narrowing. From such a process we have the feeling that art is gradually encompassing a smaller and smaller range. . . . Where are we being led?

From "Why Have We Become So Anxious?" a lecture delivered at the Congress for the Center for Human Understanding of the University of Chicago, Washington, D.C., May 1963; published in *Bridges of Human Understanding* (Chicago: University of Chicago Press, 1963), pp. 81–85.

I worked for myself, so to speak, night and day, I sought and doubted. But this self often breaks up and multiplies into all the people around me. And while I work, I often ask myself these questions: for whom do I paint? from where do I come? Towards what do I go? As always, I want to get close not only to the eyes but also to the hearts of people, so that this course of work goes beyond cerebral methods with all their theories. . . .

From a speech delivered at the inauguration ceremony for the murals at the Metropolitan Opera House, New York, 1967; published in Emily Genauer, *Chagall at the "Met"* (New York: Metropolitan Opera Association; distributed by Tudor Publishing, 1971), pp. 143–44.

A painter's drawing is really his writing. The more his writing is nonchalant, so to speak, the more it is the sign of a painter and of a poet. . . . Art is like a good child: there is no school for it. One must not try to draw well, to paint well. Schooling can only hurt. . . . Leave your talent alone. . . . I have been formed in France. I hate the Russian color, or the central European color. Their color is like their shoes. Soutine, myself, all of us left because of the color. My color was very dark when I arrived in Paris. I was potato colored, like Van Gogh. Paris is light.

From comments recorded by Pierre Schneider; published in Schneider, *Louvre Dialogues*, trans. P. Southgate (New York: Atheneum, 1971), pp. 145, 151, 157.

The Bible has fascinated me since childhood. I have always thought of it as the greatest source of poetry of all times. I have sought its reflection in life, and in art. The Bible is like a reverberation of nature and it is this mystery I have tried to convey.

All life long, whenever I had the strength, I have made these paintings in pursuit of that far-away dream, feeling at times a complete stranger, born somewhere between heaven and earth, with a world turned desert in which my soul drifted like a torch. I wanted to leave the paintings in this place so that all men could find here a certain peace, a certain spirituality, a religious feeling, a feeling of life. . . .

From the preface to the catalog of the Musée National Message Biblique Marc Chagall, Nice, France (Paris: Musées Nationaux, 1973).

A stained-glass window looks simple: matter and light. For a cathedral or for a synagogue, it's the same phenomenon: something mystical entering through the window.

Still, I was very afraid, like on a first date. Theory, technique, what do they mean? But matter, or light, that is creation! . . . I have every chance with me: the light is the light of the sky, it is that light that gives the color! And the fire that bakes the glass and the lead, it too comes from the sky, even if it comes to us through gas or electricity. . . . If what I have done holds out independently of matter, then I have won, because God is behind it. When I engraved the Bible, I went to Israel and I found there both light and earth, matter. When you are twenty, you don't think about matter; you have to have suffered, you have to be old to do so. . . .

Style is not important. To express oneself is. Painting must have psychic content. I kill any decorative impulse of mine. I attenuate the white, I soil the blue with a thousand thoughts. The psyche must find a way into the paintings. You must work on the painting with the thought that something of your soul enters it and gives it substance. A painting must blossom like something alive. It must seize something unseizable and unclear: The allure and the profound meaning of what concerns you.

Quoted in Charles Sorlier, ed., *Chagall on Chagall* (New York: Harry N. Abrams, 1979), pp. 54, 212.

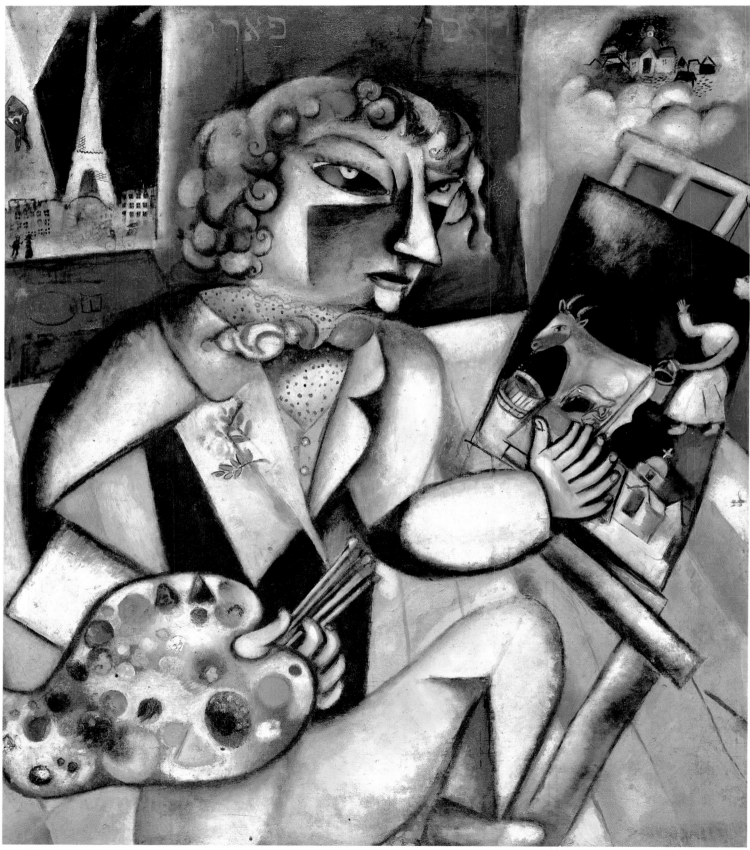

Notes on Technique

Chagall's principal medium was oil applied with brush and palette knife to sized and primed canvas. As suggested in the painting entitled *Self-Portrait with Seven Fingers,* he painted in a very traditional manner, standing at an easel, mixing his paints from tubes on a thumbhole palette. In essence, he continued to paint this way throughout his long life. When canvas was not available in his impoverished early years, he would resort to the use of bed sheets, tablecloths, clothing, and other forms of linen as a substitute, but his basic method remained the same.[1] It is obvious that, for Chagall, the expressive character of the imagery and color textures took precedence over the quality of the physical support. Even in his monumental decoration projects, such as the murals for the Kamerny Theater in Moscow (1920–21), the ceiling of the Paris Opéra (1964), and the murals at the Metropolitan Opera in New York (1967), Chagall never attempted fresco or any other form of direct wall painting. He preferred to paint the works in oil on large canvas sections in his studio (often with the help of assistants). The panels were then transported to the site and affixed to the designated wall or ceiling, where the artist performed final retouching.

Chagall was similarly traditional in his works on paper, using watercolor and brush, gouache, ink with pen and brush, pencil, charcoal, pastel, and oil crayon. When fine drawing papers were unaffordable or unavailable, he would use cardboard or other coarse papers. In a few early drawings (c. 1917) he employed fabric impressions, for which a patterned or textured fabric was lightly coated with ink and pressed onto the paper. Like many artists, Chagall often worked over the surfaces of his easel paintings, watercolors, and drawings, scraping and scratching with a brush end or other implement to create a rougher topography and a richer texture. Collage, such an important element in the work of Picasso, Braque, and their Cubist followers, appears very rarely in Chagall's art.

Chagall had an enormous love of picture making, but his love of materials per se was not as great as that of many other artists. His interest lay more in his personal methods of applying whatever materials were available to him, methods by which he achieved

93. *Self-Portrait with Seven Fingers,*
c. 1913–14
Oil on canvas, 50⅜ × 42⅛ in.
Stedelijk Museum, Amsterdam

Pages 108–9:

94. Chagall at work, Saint-Paul-de-Vence, France, c. 1958

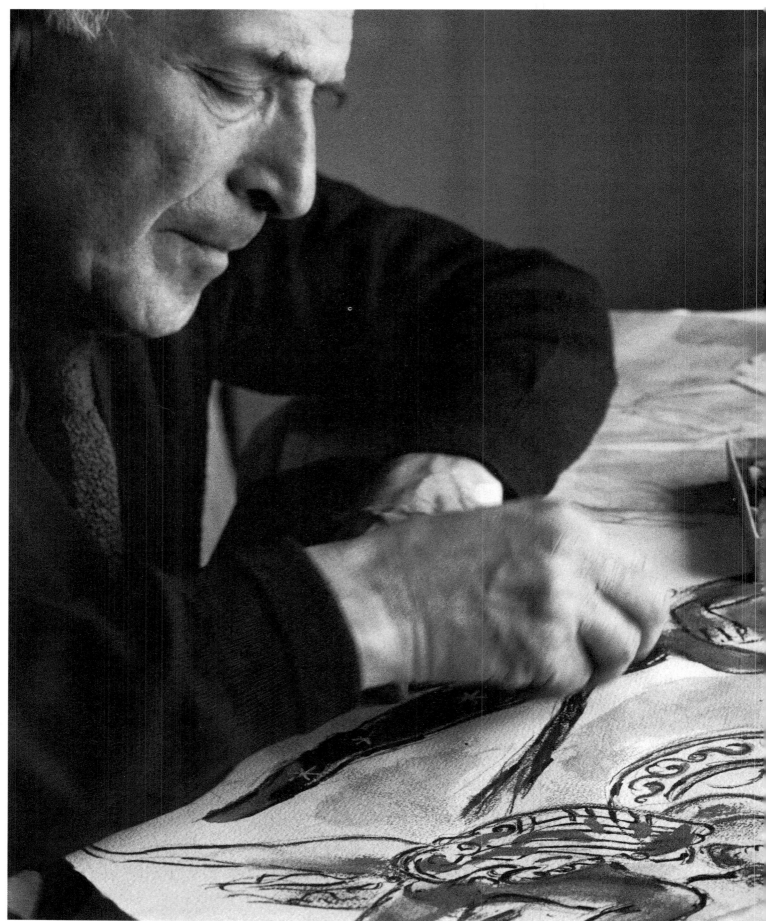

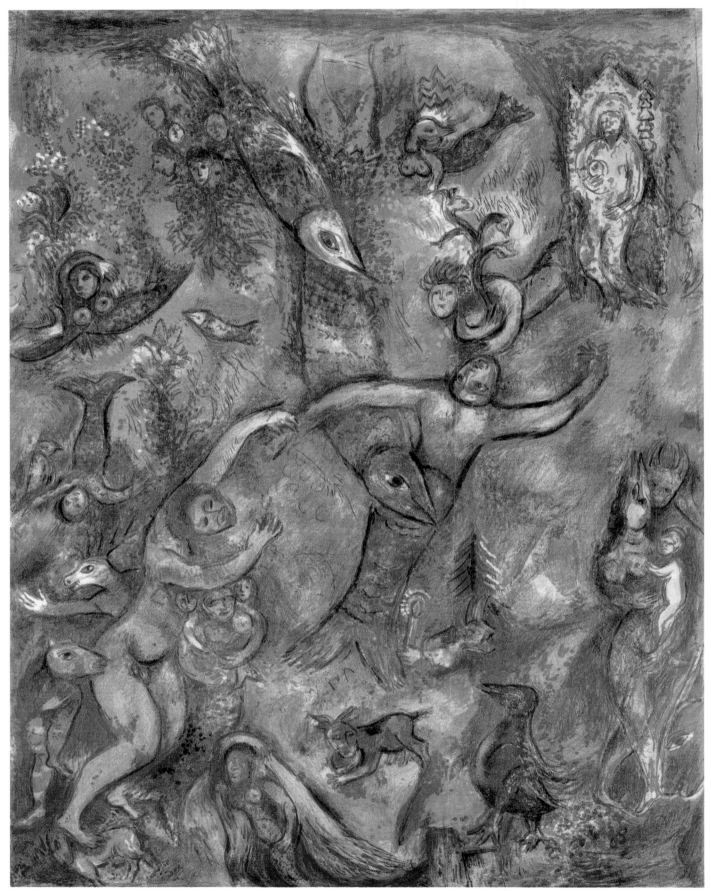

his characteristic flickering vibrations of diaphanous light. Of drawing with pastel, which he often used in preparatory sketches, he declared, "One must lay pastel down on paper with as much care as a woman does powder on her cheek. This mobile world made of feathers, petals, and shiny scales is at the same time a sensuous world."[2] When he began to make intaglio prints in the 1920s, his efforts were immediately notable for the variety of his marks in drypoint engraving, burin etching, and aquatint. Chagall almost invariably began his printmaking projects—even for black-and-white prints—with full-color studies painted in gouache. The task he would then set for himself was to recreate in the print medium, insofar as he was able, the luminosity and painterly textures of the gouache studies. To that end, he employed a wide range of blotching and smudging techniques, diverse cross-hatchings, pointed stipplings, various types of lines—some choppy, some wiry—and dotted textures created with rollers and lacquering. These varied approaches enabled him to create a great range of light-dark gradations that correspond to the color and value ranges of his paintings. In 1943 and 1944 Chagall, along with many other artists then in New York, worked occasionally with the influential, innovative printmaker Stanley William Hayter in his Atelier 17 workshop. There Chagall created some unusual etchings of circus themes using string and textile imprints.

During the 1920s and 1930s Chagall had created a few etchings that he overpainted with watercolor. However, his first true color prints were the *Arabian Nights* lithographs he produced for Kurt Wolff in 1946–47 in New York. As with his intaglio prints, Chagall began this project with studies in gouache. He then worked over the litho stones in great detail, in the desire to create color as luminous and opulent as possible.[3] In his subsequent extensive work in lithography in France, Chagall benefited from the collaboration of the Mourlot print workshop in Paris, where he was able to hone his techniques and to further enrich the vibrancy of his colors.

Although he never abandoned his fundamental approaches to picture making, after 1950 Chagall demonstrated a far greater interest in exploring the varied possibilities of diverse media. Thus he began in the early 1950s to create, for the first time, ceramic pottery (both glazed and unglazed), ceramic murals and mosaics, and even simple molded or chiseled sculptures in clay, bronze, marble, and Rogne stone. This increased interest in technical experimentation carried over to some extent into the large biblical paintings of the 1950s and 1960s, in which Chagall mixed sawdust and other materials with oil to vary the surface effects. In his studies for these large works he used oil paint applied to paper with canvas backing. In a few instances he even applied fabric collage elements cut out with pinking shears, to intensify the effect of projection and floating.

The most significant technical developments in Chagall's late career resulted from his collaborations with noted artisans in the fields of ceramics, tapestry, and stained glass. In 1952 he exhibited some small ceramic murals, created in the Madoura pottery workshop run by Georges Ramié at Vallauris, France. For his monu-

95. *Arabian Nights,* 1948
Color lithograph, 13½ × 11 in.
Samuel Stein Fine Arts, Ltd., Chicago

96

97

98

96. *Virgin and Child*, n.d.
Bronze, 26⅜ × 14⅝ × 9¾ in.
Courtesy Pierre Matisse Gallery, New York

97. *Woman Bathing*, 1953
Bronze, 14¼ × 8⅝ × 9 in.
Courtesy Pierre Matisse Gallery, New York

98. *Vava*, 1968–71
Marble, 27⅝ × 9⅛ × 6⅝ in.
Courtesy Pierre Matisse Gallery, New York

99. *Alia Eliashev*, 1919
Pencil on paper, 13 × 9¼ in.
Israel Museum, Jerusalem

99

mental late ceramic mosaics, he worked principally with the Italian mosaicist Lino Melano. Chagall's tapestries of the 1960s and 1970s were created in conjunction with Evelyne Lelong of the Gobelins Factory and with the independent weaver Yvette Cauquil-Prince. It was with Charles Marq and Brigitte Simon Marq that Chagall studied the methods and materials of stained-glass windows, and it was with their guidance and assistance that he created his great works in this medium. Chagall learned gladly from these gifted craftspeople, and he worked painstakingly with them to ensure that their collaborations yielded results as close as possible to his original vision; frequently, he even resorted to retouching with paint the finished pieces in ceramic, tapestry, and glass.

Of Chagall's work with the Marqs, Pierre Provoyeur has eloquently written:

In Chagall's art, the spirituality of an apparition is usually rendered through the vibration of his stroke, so that the traditional technique of stained glass

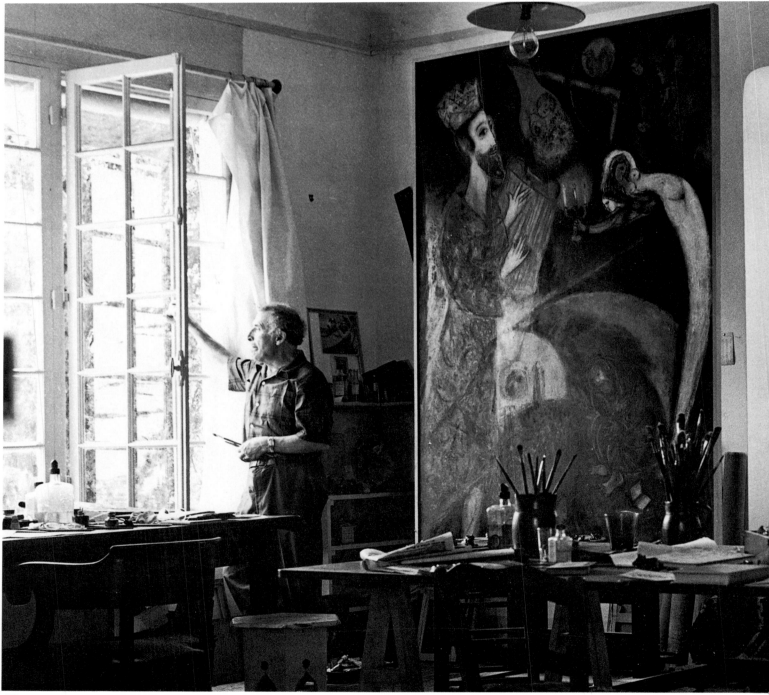

might appear ill-suited to the artist. Both his gouaches and India inks bear a considerable amount of little spots, twists of the brush or of the pen, and fabric collages in order to bring complexity to the drawing. Without using an overly dense network of lead to support glass of different color, what technique could possibly be supple enough to convey this palpitation effect?

Charles Marq and Brigitte Simon are to be credited with giving Chagall the technical means to achieve such a vibration even in glass. They were responsible for introducing the artist to the traditions of plated glass and *grisaille*, allowing Chagall to remain consistent in style and translate the qualities of his painting into a new medium."[4]

"Plated glass" is glass that has been baked and hardened, then coated with a layer of pigment. Because the superimposition of the pigments ("light mixture") creates different colors than those achieved by mixing pigments within the glass itself, this process makes it possible for the artist to attain a greater variety of colors and to achieve far more subtle color transitions and gradients within a single section of glass. Therefore, it is not always necessary to use a separate piece of glass for each different color in the composition. *Grisaille* in this sense is a gray, tin-based chemical solution that can be used for drawing on the glass and for areas of color wash. According to Provoyeur, Chagall would use this material to soften transparent colors that were letting through too much light or to sharpen contours. After the window was otherwise complete, Chagall would sometimes attack the *grisaille* in places with acid, to open up small "flashes of light."

Although Chagall continued to create his characteristic easel paintings in oil and watercolor until the end of his life, it is the monumental windows in stained glass, more than anything else, that color and define the final quarter-century of his career.

1. Marc Chagall, *My Life*, trans. Elisabeth Abbott (1922; New York: Orion Press, 1960), p. 103.
2. Chagall, in Pierre Provoyeur, *Marc Chagall: Biblical Interpretations*, trans. Charles Frankel (New York: Alpine Fine Arts Collection, 1983), p. 33.
3. Franz Meyer, *Marc Chagall*, trans. Robert Allen (New York: Harry N. Abrams, 1964), p. 526.
4. Provoyeur, *Chagall: Biblical Interpretations*, p. 245.

100. Chagall in his studio, Saint-Paul-de-Vence, France

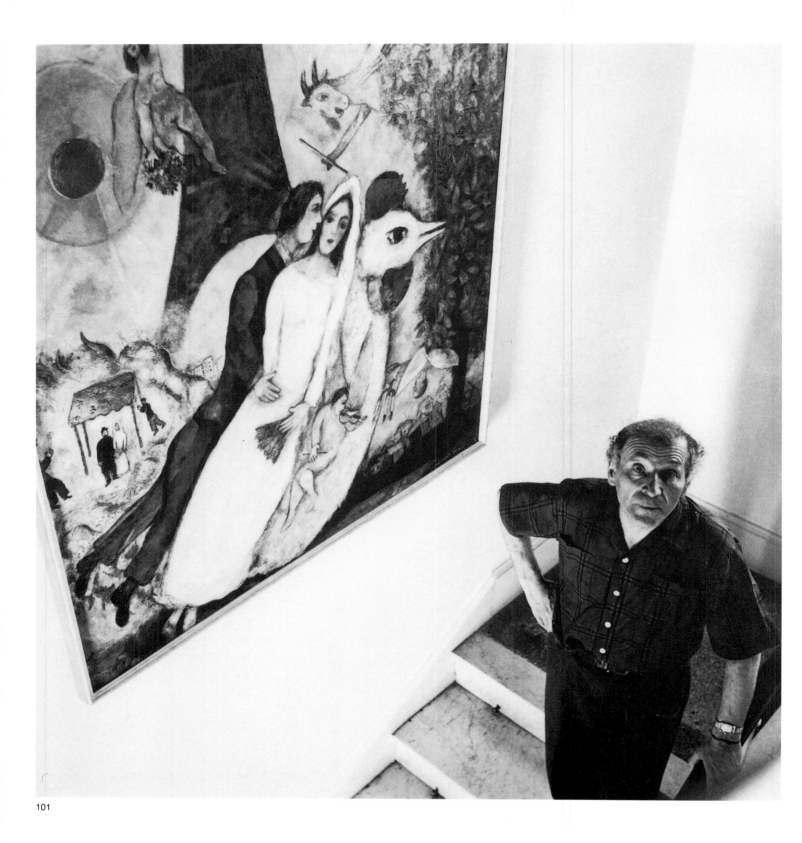

101

101. Chagall with one of his paintings,
Saint-Paul-de-Vence, France, c. 1952

Chronology By Amy Handy

1887 July 7—born in Vitebsk, Russia; first of nine children born to Zahar and Feiga-Ita Chagal. His father works for a herring merchant; his mother runs a small grocery and manages rental properties. He attends the *cheder*, the Jewish primary school, for seven or eight years, and then enrolls in the public upper school.

1906–7 Studies painting for about two months at the studio of Jehuda Pen. Meets fellow pupil Victor Mekler, who introduces him to a more prosperous circle in Vitebsk. Works briefly as a photographer's retoucher.

1907 Winter—moves to Saint Petersburg, where he lives in poverty. Jews must have a permit to live in Saint Petersburg; since this permit is granted to artisans Chagall tries, unsuccessfully, to become a sign painter. He is rescued by the lawyer and art patron Goldberg, who enables him to obtain the residence permit. April 17—awarded fee remittance at the school of the Imperial Society for the Protection of the Arts. September—granted one-year scholarship.

1908 July—leaves school; studies for a short time at Savel M. Saidenberg's private art school. Meets the influential Max Vinaver, a deputy in the Duma. Late in year—enrolls at Svanseva School, where he studies under Léon Bakst (until 1910).

1909 Returns frequently to Vitebsk. Autumn—meets Bella Rosenfeld, daughter of a wealthy jeweler in Vitebsk.

1910 April—first exhibition of work by Svanseva pupils held in Saint Petersburg. August—leaves for Paris; occupies a studio in the impasse du Maine and attends several schools, including La Grande Chaumière.

1911 Begins jotting down details of his childhood for a memoir. *The Dead Man* (1908) accepted for the Youth Union exhibition in Saint Petersburg. Spring—views work by Robert Delaunay and Fernand Léger at the Salon des Indépendants. October—work rejected by the Salon d'Automne.

1912 Winter or spring—moves to La Ruche, a structure that houses several artists' studios; there meets critics and poets, including Guillaume Apollinaire. Forms a close friendship with poet Blaise Cendrars. First participates in the Salon des Indépendants and the Salon d'Automne.

1913 March—through Apollinaire meets the German dealer Herwarth Walden, who includes some of his paintings at the First German Autumn Salon at Walden's Galerie Der Sturm in Berlin.

1914 May—the dealer Malpel promises to pay 250 francs a month for his small pictures; only one such payment is ever made. May 9—obtains a three-month visa to visit Russia. June–July—first solo show is held, at Galerie Der Sturm; travels to Berlin for the opening. June 15—goes to Vitebsk to attend his sister's wedding and to see Bella. War erupts and he stays in Russia for eight years.

1914–15 Does fifty or sixty drawings of Vitebsk.

1915 March—exhibits twenty-five works in *The Year 1915*, an important Moscow salon; receives favorable critical attention. July 25—marries Bella at her parents' home in Vitebsk. His military deferment expires and his request to become a camouflage painter is denied. Bella's brother finds him a position at the War Economy Bureau, where he spends much of his time jotting notes for an autobiography and getting to know critics, writers, poets, political thinkers, and other artists.

1916 Spring—daughter, Ida, is born.

1917 Summer—rents a cottage for his family in the countryside near Vitebsk. The Russian Revolution begins. The proposed Ministry for Cultural Affairs asks Chagall to take charge of fine arts, but Bella strongly opposes his involvement in the project. They return to Vitebsk and live with her parents.

1918 Spring—first monograph on Chagall is published, by critics Abraham Efross and Jakob Tugendhold. August—Anatoly Lunacharsky, People's Commissar for Education and Culture, approves Chagall's project to establish an art academy in Vitebsk. September 12—as Commissar for Art he organizes exhibitions and large-scale public art projects and founds the art academy and a museum.

1919 January 28—Vitebsk Academy officially opens under his direction; faculty includes El Lissitzky and Kasimir Malevich. April–July—First National Exhibition of Revolutionary Art held in the Petrograd Palace of Art; his work fills two separate rooms; the government purchases a dozen of his works from the show. Mid-year—designs sets and costumes for Nikolai Gogol's *Inspector General* for the Moscow Theater of the Revolutionary Satire (never produced). Owing partly to difficulties with Lissitzky and Malevich, he resigns his commissariat. Early autumn—briefly reinstated by his supporters.

1920 May—moves to Moscow. The Kamerny Theater in Moscow commissions him to design sets and costumes for Sholem Aleichem's *The Agents,* which opens in early 1921. Also produces sketches, which are rejected, for a Stanislavsky Theater production of J. M. Synge's *Playboy of the Western World.* Creates immense murals for permanent installation in the Kamerny auditorium.

1921 Teaches art to war orphans in the Moscow countryside.

1922 Begins compiling his autobiography, *My Life.* Summer—Lunacharsky obtains passport for him to leave the Soviet Union; his first stop is Berlin. Dealer and art historian Paul Cassirer proposes publication of Chagall's autobiography, to be illustrated with twenty dry-

point engravings. Translation difficulties delay publication of the text, but the engravings are published alone. Begins lawsuit with Walden over sales of pictures left with him eight years earlier.

1923 August—obtains visa to emigrate to France with his family. September 1—arrives in Paris.

1923–25 Autumn—produces 107 etchings illustrating Gogol's *Dead Souls* for dealer Ambroise Vollard (published in 1948).

1923–26 Repaints works from his early Paris years, which had been stolen from his studio in La Ruche while he was in Russia.

1924 June—visits Brittany. December—first retrospective held at the Galerie Barbazanges-Hodebert, Paris, where he befriends André Malraux.

1925 Summer—spends time at Montchauvet, near Nantes, France. Begins a large series of gouaches with landscape motifs.

1926 January—first American exhibition held at the Reinhardt Galleries, New York. Spring—stays at Mourillon, near Toulon, France, then goes to Nice; spends a few months at Lac Chambon in the Auvergne. Lawsuit against Walden is settled. Begins work on large preparatory gouaches for La Fontaine's *Fables,* at Vollard's request.

1927 Does *Cirque Vollard* gouaches. Signs a painting contract with Bernheim-Jeune.

Late 1928–early 1931 Works on engravings for the *Fables.*

1929 Autumn—travels to Céret, France, with Bella. Winter—buys a house in the precinct of Villa Montmorency, near Porte d'Auteuil, France.

1930 April—takes brief trip to Berlin for an exhibition of the *Fables* gouaches at the Flechtheim gallery. Vollard commissions etchings for an illustrated Bible.

1931 February—at the invitation of Meier Dizengoff, founder and mayor of Tel Aviv, travels with his family to Palestine to do research for the Bible etchings. *Ma Vie,* Bella's French translation of his autobiography, is published.

1932 Travels to Holland to study works by Rembrandt.

1933 Travels to Italy, Holland, and England; also visits Spain, where he is distressed by the political situation. November–December—large retrospective of his works held at the Kunsthalle, Basel. In Mannheim some of his works are burned in public by the Nazis.

1934 July–August—takes another trip to Spain.

1935 Spring—travels to Poland as guest of honor at the inauguration of the Jewish Institute in Vilna.

1936 Moves into a new studio in Paris, near the Trocadéro.

1937 He and his family are granted French citizenship. Spring—travels to Italy. Nazi régime orders his works removed from German museums; many are destroyed.

1939 Moves to Saint Dyé-sur-Loire, France, at the outbreak of war. Early September—he and Ida take all his pictures by taxi from his Paris studio to their new residence. Receives the Carnegie Foundation Prize.

1940 Spends time with Christian Zervos and Pablo Picasso. May 10—buys a house in Gordes in Provence, France. Mid-July—the American consul general at Marseilles and the director of the Emergency Rescue Committee deliver an invitation from the Museum of Modern Art, New York, to emigrate to the United States.

1941 Winter—Chagall's daughter and son-in-law are stripped of status as naturalized citizens. April—he and Bella go to Marseilles and obtain passports; they are arrested by the Gestapo but released by the American consul general. May 7—they go to Madrid, where the Nazis impound his packing cases containing almost a thousand paintings and drawings; a curator at the Prado retrieves the cases for them. He and Bella catch a boat from Lisbon to New York. June 23—they arrive in New York. September—they take up residence at 4 East Seventy-fourth Street. Meets Pierre Matisse, who becomes his dealer.

1942 Commissioned by Léonide Massine of the National Ballet Theater to make sets and costumes for *Aleko,* which premieres in Mexico City on September 10.

1943 August—delivers a lecture, "Some Impressions on French Painting," at Mount Holyoke College, South Hadley, Massachusetts.

1943–44 Works occasionally with the printmaker Stanley William Hayter in his Atelier 17, New York.

1944 September 2—Bella dies of a respiratory infection; Chagall stops working for over nine months.

1945 Designs sets and costumes for the National Ballet Theater's production of *The Firebird.* Winter—purchases small timber cottage at High Falls in northern New York State.

late 1945 or early 1946 Begins liaison with Virginia Haggard McNeil, who gives birth to their son, David McNeil, in 1946.

1946 April–June—large retrospective held at the Museum of Modern Art, New York. May–July—Chagall visits Paris. Autumn—works at High Falls on a commission for colored lithographs illustrating *The Arabian Nights.*

1947 Autumn—visits Paris for the opening of his retrospective exhibition at the Musée National d'Art Moderne. Attends a conference at the University of Chicago and delivers a lecture, "The Artist," which is published the same year in *The Work of the Mind.*

1948 August—returns to France; settles in Orgeval, near Saint-Germain-en-Laye. Aimé Maeght becomes his dealer in France. He is given his own room at the French pavilion in the Venice Biennale and receives the award in graphic art.

1949 January–May—lives in Saint-Jean-Cap-Ferrat, France. Develops friendship with the publisher Tériade. Executes murals for the foyer of the Watergate Theatre, London. October—buys a house in Vence, France. First works in pottery.

1950 April—first show held at Galerie Maeght, Paris, which includes a dozen ceramic pieces; creates his first lithographic poster for this exhibition.

1951 Travels to Jerusalem to attend the opening of his retrospective at the Bezalel National Art Museum.

1952 June—visits Chartres Cathedral to study the stained-glass windows. Exhibits some small ceramic murals created in the Madoura pottery, Vallauris, France. Spring—meets Valentine (Vava) Brodsky; they marry on July 12. Summer—travels to Greece with Vava; also visits Rome, Naples, and Capri. Tériade publishes *Fables.*

1953 April—travels to Turin for opening of large retrospective at the Palazzo Madama. Makes first preparatory gouaches for *Daphnis and Chloé,* commissioned by Tériade the previous year.

1954 Autumn—takes second trip to Greece.

1955 Begins work on the Biblical Message series, which he finishes in 1967.

1956 Receives first commission for stained-glass windows, for the chapel of Notre-Dame-de-Toute-Grâce in Assy (windows installed in 1957). This results in commission to create a cycle of huge windows for the restored Metz Cathedral (completed in 1968). *The Bible* is published.

1957 Retrospective of his engraved works held at the Bibliothèque Nationale, Paris. Returns to Israel. Creates first wall mosaic, *Le Coq Bleu.*

1958 February—gives lecture at a conference at the University of Chicago. Commissioned by the Paris Opéra to design sets and costumes for *Daphnis and Chloé.* Becomes friends with Charles Marq, master glassmaker and director of the Jacques Simon workshops in Reims.

1959 First windows designed for Metz are exhibited in Paris, where they are seen by the architect of the new Hadassah–Hebrew University Medical Center in Jerusalem; he invites Chagall to create a cycle of twelve windows, on the Twelve Tribes of Israel, for the hospital. Visits the University of Glasgow to receive an honorary degree. Made honorary member of the American Academy of Arts and Letters, New York.

1960 Receives honorary degree from Brandeis University, Waltham, Massachusetts. October—receives the Erasmus Prize, with Oskar Kokoschka, from the European Foundation for Culture in Copenhagen.

1961 June—*Jerusalem Windows* unveiled in Paris, in a special building erected temporarily in the courtyard of the Louvre; they then travel to New York.

1962 January–February—goes to Jerusalem for installation of windows at the medical center. Made honorary citizen of Vence.

1963 Invited by General Charles de Gaulle and André Malraux to create new ceiling decorations for the refurbished Paris Opéra, unveiled in 1964. May—delivers a speech, "Why Have We Become So Anxious?" at the Congress for the Center for Human Understanding of the University of Chicago, Washington, D.C.

1964 September 17—attends unveiling of his *Peace* window at the United Nations, New York.

1965 Receives honorary degree from the University of Notre Dame, Notre Dame, Indiana.

1966 Moves from Vence to Saint-Paul-de-Vence in the Alpes Maritimes. Works on two large murals for the Metropolitan Opera, New York.

1967 February 19—*The Magic Flute,* with sets and costumes by Chagall, opens at the Metropolitan Opera, New York. June–October—The Biblical Message series exhibited at the Louvre. Completes murals at the Metropolitan Opera, New York. Installs a press in his Mediterranean studio, enabling him to execute numerous copper engravings and monotypes.

1969 Building begins on the Musée National Message Biblique Marc Chagall, Nice, the only national museum in France devoted to a living artist. June—travels to Jerusalem for the opening of the new Knesset building, which includes his mosaics and tapestries.

1971 Spring—visits Zurich.

1972 First National Bank of Chicago commissions *The Four Seasons,* a huge outdoor mosaic. Begins illustrations for Homer's *Odyssey* (published in 1975).

1973 June—invited by the Soviet Minister of Culture, he and Vava travel to Moscow and Leningrad, where he is reunited with two of his sisters; he refuses to go to Vitebsk. July 7—Musée National Message Biblique Marc Chagall is inaugurated on his birthday.

1974 Receives triumphal welcome in Chicago at the unveiling of *The Four Seasons.*

1975 March–September—works on lithographic illustrations for Shakespeare's *The Tempest.*

1977 January 1—awarded the Grand Cross of the Legion of Honor. Travels to Israel, where he is made an honorary citizen of Jerusalem.

1978 June—travels to Florence for the opening of an exhibition of his works at the Pitti Palace.

1979 *The America Windows,* a three-panel stained-glass work, is unveiled at the Art Institute of Chicago.

1982 Retrospective held at the Moderna Museet, Stockholm.

1985 Major retrospective held at the Philadelphia Museum of Art, which he is unable to attend. March 28–Chagall dies at his home in Saint-Paul-de-Vence.

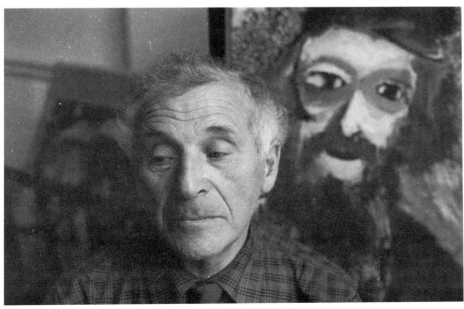

102. Chagall with one of his paintings, Paris, c. 1957

Exhibitions

1914

Chagall, Galerie Der Sturm, Berlin, June–July.

1923

Sonderausstellung Marc Chagall, Galerie Lutz, Berlin, January.

1924

Marc Chagall, Galerie Le Centaure, Brussels, March 22–April 2.

Oeuvres de Marc Chagall, 1908–1924, Galerie Barbazanges-Hodebert, Paris, December 17–30.

1925

Ausstellung Marc Chagall, Kölnischer Kunstverein, Cologne, Germany, April.

Gemälde von Marc Chagall, 1908–1925, Galerie Ernst Arnold, Dresden, Germany, May–June.

Marc Chagall, Galerie des Quatre-Chemins, Paris.

1926

Chagall, Reinhardt Galleries, New York, January 9–30.

Trente Peintures de Marc Chagall, Galerie Katia Granoff, Paris, June 14–July 5.

Marc Chagall: Travaux de l'été, Galerie Katia Granoff, Paris, November 22–December 11.

1928

Chagall: Gouaches et illustrations, Galerie Le Portique, Paris, March 10–17.

1929

Gouaches de Chagall, Galerie l'Epoque, Brussels, March.

1930

La Fontaine par Chagall, Galerie Bern-heim-Jeune, Paris, February 10–21, and tour to Galerie Le Centaure, Brussels; Galerie Flechtheim, Berlin.

Paintings by Chagall, Demotte Gallery, New York, November 10–December 6.

1931

Vingt Tableaux récents et quelques dessins de jeunesse inédits par Marc Chagall, Galerie Le Portique, Paris, June 13–30.

1932

Marc Chagall, Maatschappij Arti et Amicitiae, Amsterdam, March 12–April 3.

1933

Marc Chagall, Kunsthalle Basel, Basel, Switzerland, November 4–December 3.

1934

Gallery Dra Feigla, Prague, November.

1935

Paintings and Gouaches by Marc Chagall, Leicester Galleries, London, April–May.

Marc Chagall, Jewish Cultural Institute, Vilna, Soviet Union, Summer.

1936

Marc Chagall, New Art Circle, J. B. Neumann, New York, November 30–December 31.

1937

Gouaches de Chagall, Galerie Renou et Colle, Paris, October 26–November 13.

1938

Recent Works by Chagall, Mayor Gallery, London, January.

Marc Chagall, Palais des Beaux-Arts, Brussels, January 22–February 13.

Marc Chagall, Lilienfeld Galleries, New York, February 28–March 26.

Marc Chagall, Lilienfeld Galleries, New York, December 5–January 7, 1939.

1940

Marc Chagall, Galerie Mai, Paris, January 26–February 24.

1941

Marc Chagall: Retrospective, 1910–1941, Pierre Matisse Gallery, New York, November 23–December 13.

1942

Marc Chagall: 25 Paintings and Gouaches of 1931 to 1941, Pierre Matisse Gallery, New York, October 13–November 7.

1943

Marc Chagall: Paintings, Gouaches, Pierre Matisse Gallery, New York, November 2–27.

1944

Chagall, Pierre Matisse Gallery, New York, October 31–November 30.

1945

Marc Chagall, James Vigeveno Galleries, Los Angeles, April 1–30.

Marc Chagall, Gallery of Jewish Art, New York, May 2–June 15.

Marc Chagall, Pierre Matisse Gallery, New York, June 5–23.

Quelques Oeuvres de Marc Chagall, Galerie de Berri, Paris, October 3–23.

Marc Chagall, Galerie Vendôme, Paris, December 15–January 15, 1946.

1946

Chagall, Paintings 1945–1946, Pierre Matisse Gallery, New York, February 5–March 2.

Marc Chagall, Museum of Modern Art, New York, April 4–June 23, and tour to Art Institute of Chicago.

1947

Marc Chagall: Recent Paintings, Gouaches for "A Thousand and One Nights," Pierre Matisse Gallery, New York, April 8–26.

Marc Chagall: Peintures, 1908–1947, Musée National d'Art Moderne, Paris, October 17–December 22, and tour to Stedelijk Museum, Amsterdam.

1948

Marc Chagall: An Exhibition of Paintings, Prints, Book Illustrations, and Theatre Designs, 1908–1947, Tate Gallery, London, February 4–29.

Marc Chagall, Pierre Matisse Gallery, New York, November 2–27.

The Arabian Nights, Kleemann Gallery, New York, November 27–December 24.

1949

Marc Chagall, Galerie Rosengart, Lucerne, Switzerland, July 4–October 4.

Illustrations to Gogol, "The Dead Souls," Art Institute of Chicago, October 7–January 1950.

Chagall, Städtische Kunsthalle Düsseldorf, Düsseldorf, West Germany, November 20–January 1, 1950.

1950

Marc Chagall, Galerie Maeght, Paris, March–April.

Marc Chagall, Kunsthaus Zurich, December 9–January 28, 1951.

1951

Marc Chagall, Kunsthalle Bern, February 4–March 4.

Recent Paintings of Marc Chagall, Knoedler Galleries, New York, April 16–May 5.

Chagall, Perls Galleries, Beverly Hills, California.

Marc Chagall: Oeuvres, 1908–1951, Bezalel National Art Museum, Jerusalem, and tour to Tel Aviv Museum; Haifa Museum of Modern Art, Haifa, Israel.

Marc Chagall: Peintures, gouaches, lavis, eaux-fortes, Galerie Samlaren, Stockholm.

1952

Galerie des Ponchettes, Nice, France, February–March.

Sculptures et céramiques de Chagall, Galerie Maeght, Paris, March–April.

Le Favole di Chagall, Galleria dell'Obelisco, Rome, November.

Sculptures, Ceramics, Etchings for the Fables of La Fontaine, Curt Valentin Gallery, New York, November 18–December 13.

Chagall Etchings: Fables of La Fontaine, Arts Club of Chicago.

Marc Chagall, Musée de l'Athénée, Geneva.

1953

Marc Chagall, Paintings and Graphics, Santa Barbara Museum of Art, Santa Barbara, California, February 10–March 7.

Marc Chagall: Zeichnungen, Aquarelle, Graphik, Graphische Sammlung Albertina, Vienna, February–March.

L'Opera di Marc Chagall, Museo Civico, Palazzo Madama, Turin, Italy, April–June.

1954

Chagall, Salle de l'Emulation, Liège, Belgium, April 24–May 6.

Marc Chagall: Paris, Galerie Maeght, Paris, June–August.

1955

Marc Chagall: Bibel-Illustrationen, Clemens Sels Museum, Neuss, West Germany, May 1–July 31.

Marc Chagall, Kestner-Gesellschaft, Hanover, West Germany, May 25–June 26.

Marc Chagall: Graphik, Kestner-Museum, Hanover, West Germany, May 25–June 26.

Marc Chagall, Kunstverein Freiburg, Freiburg, West Germany, August 7–September 4.

Marc Chagall, Galleria La Medusa, Rome.

1956

Marc Chagall, Perls Galleries, New York, March 12–April 14.

Marc Chagall: Werke aus den letzten 25 Jahren, Kunsthalle Basel, Basel, Switzerland, August 25–October 21.

Marc Chagall: Graphik aus den Jahren 1950–1956, Galerie Klipstein und Kornfeld, Bern, October 26–December 1.

Marc Chagall, 1950–1956, Kunsthalle Bern, October 27–November 29.

Chagall: Recent Works, Galerie Chalette, New York, November 13–December 8.

Chagall: Soixante-quinze Dessins, 1907–1927, Stedelijk Museum, Amsterdam, December 7–January 14, 1957, and tour to Palais des Beaux-Arts, Brussels.

Marc Chagall: Werk van lateren jaren, Stedelijk Museum, Amsterdam, December 7–January 14, 1957, and tour to Palais des Beaux-Arts, Brussels.

1957

Hommage à Marc Chagall, Salle de la Bourse, Cercle Royal Artistique et Littéraire de Charleroi, Charleroi, Belgium, March 23–April 11.

Seventieth Anniversary Exhibition: Chagall, Pasadena Art Museum, Pasadena, California, May 28–July 28.

Marc Chagall: Peintures 1955–1957, Galerie Maeght, Paris, July–August.

Marc Chagall, Galerie Welz, Salzburg, Austria, Summer.

Marc Chagall: Des graphische Werk, Kunstmuseum Basel, Basel, Switzerland, November 3–December 8.

Marc Chagall—Seventieth Birthday, Museum of Modern Art, New York, December 18–February 23, 1958.

Bible Chagall, Bezalel National Art Museum, Jerusalem, and tour to Tel Aviv Museum.

L'Oeuvre gravé de Marc Chagall, Bibliothèque Nationale, Paris.

1958

Painting and Graphic Work by Chagall, Renaissance Society, Chicago, February 15–March 8.

Marc Chagall: Oeuvre gravé, Galerie des Ponchettes, Nice, Fance, February–March.

Chagall: A Selection of Paintings from American Museums and Private Collections, Galerie Chalette, New York, March–April.

Marc Chagall: Eaux-fortes, pointes-sèches, bois, Galerie Gérald Cramer, Geneva, June 17–July 30.

Bibel-Illustrationen, Frankfurter Kunstverein.

Marc Chagall, Galerie St. Stephan, Vienna.

1959

Marc Chagall, Kunstverein im Hamburg, Hamburg, West Germany, February 6–March 22, and tour to Haus der Kunst, Munich, West Germany.

Chagall: Lithographs, 1950–1956, University Print Room, University of Glasgow, June 1–19, and tour to Arts Council Gallery, Edinburgh.

Marc Chagall, Musée des Arts Décoratifs, Paris, June–October.

1960

Marc Chagall: Gouachen, Aquarelle, Zeichnungen, 1911–1959, Galerie Klipstein und Kornfeld, Bern, April 30–May 28.

Marc Chagall, Musée des Beaux-Arts, Reims, France, June–August.

Marc Chagall, Statens Museum for Kunst, Copenhagen, October 22–November 13.

Marc Chagall: Commedia dell'arte, Städelsches Kunstinstitut, Frankfurt, November 18–December 10.

1961

Marc Chagall: Graphik aus den Jahren 1950–1960, Städtische Kunsthalle Düsseldorf, Düsseldorf, West Germany, April 19–May 22.

Chagall: Vitraux pour Jérusalem, Musée des Arts Décoratifs, Paris, June 16–September 30, and tour to Museum of Modern Art, New York.

Hommage à Marc Chagall: Exposition rétrospective, Casino Communal, Knokke-le-Zoute, Belgium, July 1–September 15.

1962

Marc Chagall, Galerie Maeght, Paris, June–July.

Marc Chagall, Musée des Beaux-Arts, Le Locle, Switzerland, September 9–October.

1963

Marc Chagall: Gouaches pour l'affiche de Nice, Musée Masséna, Nice, France, February–April.

Marc Chagall et la Bible, Musée Rath, Geneva, June 30–August 26.

Marc Chagall: Céramiques, Galerie Madoura, Cannes, France, September.

Marc Chagall: Seventy-fifth Anniversary Exhibition, La Jolla Art Center, La Jolla, California, October 1–November 11.

1964

Musée des Beaux-Arts, Rouen, France, May.

1967

Musée du Louvre, Paris, June–October.

Hommage à Chagall, Fondation Maeght, Saint-Paul-de-Vence, France.

1969

Hommage à Chagall, Grand Palais, Paris, December–March 1970.

1970

Bibliothèque Nationale, Paris, January–May.

1974

Maquettes pour l'oeuvre monumentale Marc Chagall, Musée National Message Biblique Marc Chagall, Nice, France, July–September.

1975

Marc Chagall: Work on Paper, Solomon R. Guggenheim Museum, New York, June 8–September 28.

1977

Marc Chagall: A Celebration, Pierre Matisse Gallery, New York, May 17–June 11.

1980

Marc Chagall: Gravures, monotypes, livres illustrés, Musée Rath, Geneva, October 2–November 16.

1981

Galerie Maeght, Paris, May 6–July 10.

The Circus: Recent Works, Pierre Matisse Gallery, New York, May 12–June 6.

Galerie Strunk-Hilgers, Mönchengladbach, West Germany, November 20–December 20.

1982

Galerie Orangerie-Reinze, Cologne, West Germany, September 24–November 3.

Marc Chagall, Moderna Museet, Stockholm, September 25–December 5.

Marc Chagall: Paintings, Gouaches, Temperas, and Wash Drawings, Pierre Matisse Gallery, New York, November 16–December 11.

Marc Chagall: Die Werke aus dem Besitz des Museums, Kunstverein Hanover, Hanover, West Germany, December 13–February 1983.

1983

The Etchings of Marc Chagall, Dimock Gallery, George Washington University, Washington, D.C., June 9–July 29.

Marc Chagall: Rétrospective de l'oeuvre peint, Fondation Maeght, Saint-Paul-de-Vence, France, July 7–October 15.

1985

Marc Chagall: Retrospektive, Kestner-Gesellschaft, Hanover, West Germany, February 1–April 8.

Marc Chagall, Royal Academy of Arts, London, January 11–March 31, and tour to Philadelphia Museum of Art.

Selected Group Exhibitions

1910

Svanseva School, Saint Petersburg, Russia, April 20–May 9.

1911

Exhibition of the Youth Union, Salon of Prince Bariatinsky, Saint Petersburg, Russia, April.

1913

Salon des Indépendants, Paris, March 19–May 18. Also included in 1914.

1915

The Year 1915, Mikhailova Art Salon, Moscow.

1916

Contemporary Russian Art, Gallery Dobitchina, Petrograd, Russia, April 3–19.

1924

Deuxième Exposition des peintures-graveurs indépendants, Galerie Barbazanges-Hodebert, Paris. Also included in 1925 and 1928.

1935

Peintres instinctifs, naissance de l'expressionisme, Galerie Beaux-Arts et Gazette des Beaux-Arts, Paris, December–January 1936.

1936

Fantastic Art, Dada, Surrealism, Museum of Modern Art, New York, December–January 1937.

1937

Les Maîtres de l'art indépendant 1895–1937, Petit-Palais, Paris.

1942

Phillips Memorial Gallery, Washington, D.C., November 29–January 4, 1943.

1945

Soutine and Chagall, Institute of Modern Art, Boston, January 24–February 5.

1947

Les Maîtres de la peinture française contemporaine, Kunstverein Freiburg, Freiburg, West Germany, opened October 20.

1948

XXIV Venice Biennale, June–September.

1950

French Religious Art, Stedelijk van Abbemuseum, Eindhoven, The Netherlands.

1952

Cinquante Ans de peinture française dans les collections particulières, Musée des Arts Décoratifs, Paris.

1955

De Toulouse-Lautrec à Chagall: Dessins, aquarelles, gouaches, Palais des Beaux-Arts, Brussels, March 3–April 22.

Chagall and de Chirico, Museum of Fine Arts, Houston, April 3–May 1.

Documenta, Museum Fridericianum, Kassel, West Germany, July 11–October 11.

1957

IV Bienal, São Paulo, Brazil.

1959

Französische Zeichnungen des 20. Jahrhunderts, Hamburger Kunsthalle, Hamburg, West Germany, September 3–November 15.

1973

Tretiakov Gallery, Moscow. Exhibition organized by the Soviet government.

1982

Bilder sind nicht Verboten, Städtische Kunsthalle, Düsseldorf, Düsseldorf, West Germany, August 28–October 24.

Der Traum von Leben, Museum Haus Lange, Krefeld, West Germany, September 5–October 24.

Public Collections

Amsterdam, The Netherlands, Stedelijk Museum

Basel, Switzerland, Offentliche Kunstsammlung, Kunstmuseum Basel

Bern, Switzerland, Kunstmuseum Bern

Buffalo, New York, Albright-Knox Art Gallery

Chicago, Illinois, Art Institute of Chicago

Chicago, Illinois, First National Bank of Chicago

Chichester, England, Chichester Cathedral

Cologne, West Germany, Wallraf-Richartz-Museum

Düsseldorf, West Germany, Kunstsammlung Nordrhein-Westfalen

Eindhoven, The Netherlands, Stedelijk van Abbemuseum

Florence, Italy, Galleria degli Uffizi

Frankfurt, West Germany, Frankfurt Theater

Göteborg, Sweden, Göteborgs Konstmuseum

Hamburg, West Germany, Hamburger Kunsthalle

Helsinki, Finland, Art Museum of the Ateneum

Jerusalem, Israel, Bezalel National Art Museum

Jerusalem, Israel, Israel Museum

Jerusalem, Israel, Knesset

Jerusalem, Israel, Synagogue of the Medical Center, Hadassah–Hebrew University

Leningrad, Soviet Union, Ministry of Culture

Leningrad, Soviet Union, State Russian Museum

London, England, Tate Gallery

Los Angeles, California, Los Angeles County Museum of Art

Lugano, Switzerland, Thyssen-Bornemisza Collection

Mainz, West Germany, Church of Saint-Etienne

Metz, France, Cathédrale Saint-Etienne

Moscow, Soviet Union, Tretiakov Gallery

New York, New York, Metropolitan Opera, Lincoln Center

New York, New York, Museum of Modern Art

New York, New York, Solomon R. Guggenheim Museum

New York, New York, United Nations

Nice, France, Musée National Message Biblique Marc Chagall

Nice, France, Université de Droit et Sciences Economiques

Paris, France, Musée d'Art Moderne de la Ville de Paris

Paris, France, Musée National d'Art Moderne, Centre Georges Pompidou

Paris, France, Paris Opéra

Philadelphia, Pennsylvania, Philadelphia Museum of Art

Pocantico Hills, New York, Pocantico Hills Chapel

Prague, Czechoslovakia, Narodni Galerie v Prague

Reims, France, Reims Cathedral

Saint Louis, Missouri, Saint Louis Museum of Art

Saint-Paul-de-Vence, France, Fondation Marguerite et Aimé Maeght

Sarrebourg, France, Chapel of Penitents

Tel Aviv, Israel, Tel Aviv Museum

Tokyo, Japan, Galerie Tamenaga

Toronto, Canada, Art Gallery of Ontario

Zurich, Switzerland, Fraumünster Church

Zurich, Switzerland, Kunsthaus Zurich

103

103. *Jew in Bright Red,* 1914–15
Oil on cardboard, 39⅜ × 31⅞ in.
State Russian Museum, Leningrad

Selected Bibliography

Interviews, Statements, and Writings

Abel, Raymond. "Interview with Marc Chagall." *League*, no. 1, April 1942.

Chagall, Marc. "Reflections on the People's Fine Arts Academy, Vitebsk" (in Russian). *Schkola revoluzia* (Vitebsk), nos. 24–25 (August 16, 1919).

———. *My Life*. Translated by Elisabeth Abbott. 1922; New York: Orion Press, 1960.

———. "My First Teacher, Pen" (in Russian). *Razsviet* (Paris), January 30, 1927.

———. "Réponse à une enquête: 'Pouvez-vous dire quelle est la rencontre capitale de votre vie?'" *Minotaure*, nos. 3–4 (1933).

———. "Réponse à une enquête: 'Sur la crise de la peinture.'" *Beaux-Arts*, August 19, 1935.

———. "Réponse à une enquête: 'Sur l'art d'aujourd'hui.'" *Cahiers d'art* 10, nos. 1–4 (1935): 37, 39–44.

———. "Quelques Impressions sur la peinture française." Reprinted from a lecture delivered at the Pontigny Conference, August 1943, at Mount Holyoke College, South Hadley, Mass. Reprinted in *Marc Chagall*, Paris: Musée des Arts Décoratifs, 1959.

———. "Message aux peintres français." *Le Spectateur des arts*, December 1944.

———. "L'Art de la rectitude et de la clarté." *Naje Lehn* 18 (June 1945). Talk given at reception in honor of Chagall and Itzik Feffer, April 30, 1944.

———. *Le Cirque*. Paris: Tériade, 1967.

———. *Poèmes, 1909–1972*. Translated by Philippe Jaccottet. Geneva: Gérald Cramer, 1975.

Charensol, Georges. "Chez Marc Chagall." *Paris-Journal*, May 16, 1924. Interview.

Courthion, Pierre. "Marc Chagall." *Les Nouvelles littéraires*, April 30, 1932. Interview.

D'Assailly, Gisèle. "Visite à Chagall." *Le Figaro littéraire*, March 1, 1952. Interview.

Guenne, Jacques. "Marc Chagall." *L'Art vivant* 3 (December 15, 1927). Interview.

Sweeney, James Johnson. "An Interview with Marc Chagall." *Partisan Review* 11 (Winter 1944).

Major Illustrated Books

Chagall, Marc. *Les Ames mortes*. By Nicolas Gogol. Translated by Henri Mongault. 2 vols. Paris: Tériade, 1948.

———. *Arabian Nights*. New York: Pantheon Books, 1948.

———. *Fables*. By La Fontaine. 2 vols. Paris: Tériade, 1952.

———. *The Bible*. 2 vols. Paris: Tériade, 1956.

———. *Daphnis et Chloé*. By Longus. 2 vols. Paris: Tériade, 1961.

———. *L'Odyssée*. By Homer. Paris: Fernand Mourlot, 1975.

———. *La Tempête*. By William Shakespeare. Monte Carlo: André Sauret, 1975.

Monographs and Solo-Exhibition Catalogs

Adhémar, Jean. Introduction to *Les Affiches de Chagall*. Preface by Léopold Sédar Senghor. Paris: Draeger-Vilo, 1975.

Adhémar, Jean, and Maryvonne Sauvage. *L'Oeuvre gravé de Marc Chagall*. Paris: Bibliothèque Nationale, 1957.

Alexander, Sydney. *Marc Chagall: A Biography*. New York: G. P. Putnam's Sons, 1978.

———. *Marc Chagall: An Intimate Biography*. New York: Paragon House, 1988.

Amishai-Maisels, Ziva. *Tapestries and Mosaics of Marc Chagall at the Knesset*. Foreword by Israel Yeshayahu. New York: Tudor Publishing, 1973.

Arland, Marcel, and Lionello Venturi. *Marc Chagall: Paris*. Paris: Galerie Maeght. Published as a special number of *Derrière le miroir*, nos. 66–68 (1954).

Ausstellung Marc Chagall. Cologne, West Germany: Kölnischer Kunstverein, 1925.

Bachelard, Gaston, Charles Estienne, and Ambroise Vollard. *Sculptures et céramiques de Chagall*. Paris: Galerie Maeght. Published as a special number of *Derrière le miroir*, nos. 44–45 (1952).

Brinton, Christian. "The Essence of Chagall." Preface to *Chagall*. New York: Reinhardt Galleries, 1926.

Brion, Marcel. *Chagall*. Translated by A.H.N. Molesworth. New York: Harry N. Abrams, 1962.

Cain, Julien. Preface to *Douze maquettes pour*

les vitraux de Jérusalem. Paris: A. C. Mazo, 1964.

Cassou, Jean. Preface to *Marc Chagall: Peintures 1908–1947*. Paris: Musée National d'Art Moderne, 1947.

———. *Chagall*. Translated by Alisa Jaffa. New York: Frederick A. Praeger, 1965.

Chagall, Bella. *First Encounter*. Translated by Barbara Bray. New York: Schocken Books, 1983.

Chagall, Marc, and Charles Sorlier. *Chagall Lithographs VI: 1978–1985*. New York: Crown Publishers, 1986.

Chagall: Lithographs 1950–1956. Glasgow: University of Glasgow Press, 1959.

Cogniat, Raymond. *Chagall*. Translated by Anne Ross. New York: Crown Publishers, 1965.

Compton, Susan, ed. *Chagall*. New York: Harry N. Abrams, 1985.

Cramer, Gérald, ed. *Marc Chagall: Gravures, monotypes, livres illustrés*. Geneva: Musée Rath, 1980.

Crespelle, Jean-Paul. *Chagall*. Translated by Benita Eisler. New York: Coward-McCann, 1970.

de la Tourette, Gilles. *Marc Chagall*. Basel, Switzerland: Kunsthalle Basel, 1933.

Erben, Walter. *Marc Chagall*. Rev. ed. Translated by Michael Bullock. New York: Frederick A. Praeger, 1966.

Foster, Joseph K. *Marc Chagall: Posters and Personality*. New York: Reynal, 1966.

Freund, Miriam Kottler. *Jewels for a Crown: The Story of the Chagall Windows*. Foreword by René d'Harnoncourt. New York: McGraw-Hill, 1963.

Genauer, Emily. *Chagall at the Met*. New York: Metropolitan Opera Association, distributed by Tudor Publishing, 1971.

Goldstein, Chaja, and H.L.C. Jaffé. Preface to *Marc Chagall*. Amsterdam: Stedelijk Museum, 1947.

Greenfeld, Howard. *Marc Chagall: An Introduction*: Chicago: Follett Publishing Company, 1967.

Guérin, Jacques. Introduction to *Marc Chagall*. Paris: Musée des Arts Décoratifs, 1959.

Haftmann, Werner. *Chagall*. Translated by Heinrich Baumann and Alexis Brown. New York: Harry N. Abrams, 1973.

Lassaigne, Jacques. *L'Opera di Marc Chagall*. Turin, Italy: Museo Civico di Torino, 1953.

———. *Marc Chagall, peintures 1955–1957*. Paris: Galerie Maeght, 1957.

———. *Marc Chagall: The Ceiling of the Paris Opéra*. Translated by Brenda Gilchrist. New York: Frederick A. Praeger, 1966.

———. *Chagall: Unpublished Drawings*. Geneva: Skira, 1968.

———. *Marc Chagall: Drawings and Water Colors for the Ballet*. Translated by Joyce Reeves. New York: Tudor Publishing, 1969.

Le Targat, François. *Marc Chagall*. Translated by Kenneth Lyons. New York: Rizzoli, 1985.

Leymarie, Jean. *Monotypes Marc Chagall*. 2 vols. Geneva: Gérald Cramer, 1966–76.

———. *The Jerusalem Windows*. Translated by Elaine Desautels. New York: George Braziller, 1975.

Leymarie, Jean, and Thomas M. Messer. *Marc Chagall: Work on Paper*. Rutland, Vt.: Charles E. Tuttle Co., 1975.

McLane, James M. Preface to *Marc Chagall: Paintings and Graphics*. Santa Barbara, Calif.: Santa Barbara Museum of Art, 1953.

McMullen, Roy. *The World of Marc Chagall*. Photographs by Izis Bidermanas. Garden City, N.Y.: Doubleday and Co., 1968.

Maquettes pour l'oeuvre monumentale Marc Chagall. Nice, France: Musée National de Message Biblique Marc Chagall, 1974.

Marc Chagall. Brussels: Palais des Beaux-Arts, 1938.

Marc Chagall. Brussels: Palais des Beaux-Arts, 1957.

Marc Chagall: Retrospektive. Hanover, West Germany: Kestner-Gesellschaft, 1985.

Marc Chagall. Twenty-five Paintings and Gouaches of 1931 to 1941. New York: Pierre Matisse Gallery, 1942.

Marteau, Robert. *The Stained-Glass Windows of Chagall, 1957–1970*. Afterword by Charles Marq. New York: Tudor Publishing, 1973.

———. *Chagall Lithographs V: 1974–1979*. New York: Crown Publishers, 1984.

Meyer, Franz. *Marc Chagall*. Translated by Robert Allen. New York: Harry N. Abrams, 1964.

Narkiss, M., Marc Chagall, and Lionello Venturi. *Marc Chagall: Oeuvres, 1908–1951*. Jerusalem: Bezalel National Art Museum, 1951.

Provoyeur, Pierre. *Chagall*. 3 vols. Nice, France: Musée National du Message Biblique Marc Chagall, 1975.

Rüdlinger, A. Preface to *Marc Chagall*. Bern: Kunsthalle Bern, 1951.

Schmalenbach, Werner. *Chagall*. Translated by M. Ledivelec. New York: Crown Publishers, 1965.

Sorlier, Charles. *Les Céramiques et sculptures de Chagall*. Preface by André Malraux. Monte Carlo: André Sauret, 1972.

———. *The Lithographs of Chagall, 1969–1973*. New York: Crown Publishers, 1974.

———, ed. *Chagall's Posters: A Catalogue Raisonné*. Preface by Jean Adhemar. New York: Crown Publishers, 1975.

———, ed. *Chagall by Chagall*. Translated by John Shepley. New York: Harry N. Abrams, 1979.

Sweeney, James Johnson, and Carol O. Schniewind. *Marc Chagall*. New York: Museum of Modern Art, in collaboration with the Art Institute of Chicago, 1946. Reprinted 1970.

Venturi, Lionello. *Marc Chagall*. New York: Pierre Matisse Gallery, 1945.

———. *Marc Chagall*. Zurich: Kunsthaus Zurich, 1950.

———. *Chagall*. Translated by S.J.C. Harrison and James Emmons. New York: Skira, 1956.

Venturi, Lionello, and Jean Cassou. *L'Opera di Marc Chagall*. Turin, Italy: Museo Civico, 1953.

Verdet, André. *Chagall's World: Reflections from the Mediterranean*. Originally published as *Chagall Méditerranéen*. Garden City, N.Y.: Doubleday and Co., Dial Press, 1984.

Vollard, Ambroise. "J'édite les Fables de La Fontaine et je choisis Chagall comme illustrateur." Preface to *La Fontaine par Chagall*. Paris: Galerie Bernheim-Jeune, 1930.

Voznesensky, Andrei, et al. *Chagall Discovered: From Russian and Private Collections*. New York: Hugh Lauter Levin Associates, 1988.

Periodicals, Books, and Group-Exhibition Catalogs

Aillaud, C. "*Architectural Digest* Visits: Marc Chagall." *Architectural Digest* 41 (August 1984): 74–83.

Aragon, Louis. "Chagall l'admirable." *XXᵉ Siècle*, no. 38 (June 1972): 96–107.

Barr, Alfred H., Jr. *Fantastic Art, Dada, Surrealism*. New York: Museum of Modern Art, 1936.

Cogniat, Raymond. *Peintres instinctifs, naissance de l'expressionisme*. Paris: Galerie Beaux-Arts et Gazette des Beaux-Arts, 1935.

Dalevèze, J. "Le Musée Chagall à Nice." *Oeil*, nos. 264–65 (July–August 1977): 20–27.

Decker, Andrew. "Whose Chagall Is It Anyway?" *Artnews* 86 (December 1987): 21.

D'Harnoncourt, A. Obituary in *Artnews* 84 (Summer 1985): 99.

Duchen, Monica Bohm. "Religion and Marc Chagall." *Art and Artists*, no. 220 (January 1985): 18–21.

Esteban, Claude. "Chagall." Special number of *Derrière le miroir*, December 1969.

Gibson, M. "Payable in Paint." *Artnews* 87 (Summer 1988): 47.

Hermant, André, C. Marq, and Pierre Provoyeur. "Message Biblique Marc Chagall." *Revue du Louvre* 23, no. 3 (1973): 207–12.

Hodin, J. P. "Marc Chagall in Search of the Primary Sources of Inspiration." In *The Dilemma of Being Modern*. London: Routledge and Kegan Paul, 1956.

———. "Chagall's Testament of Beauty." *Art and Artists*, no. 225 (June 1985): 16–18.

Lascault, G. "La Prose de Chagall." *Chroniques de l'art vivant*, no. 30 (May 1972): 12–13.

Les Maîtres de l'art indépendant, 1895–1937. Paris: Petit-Palais, 1937.

Maeght, Aimé. "Les Chemins de l'amitié." *Derrière le miroir*, no. 225 (October 1977): 1–23.

"Marc Chagall's Designs for 'Aleko' and 'The Firebird.' " *Dance Index* 4 (November 1945): 188–204.

McNally, Janet. "Chagall in Glass." *Stained Glass* 80 (Fall 1985): 227–31.

Mosby, Aline. "Chagall at 90: 'When You Have Love, You Work. That Is My Life.' " *Artnews* 76 (Summer 1977): 44–48.

Ragon, Michel. "L'Oeuvre fabuleuse de Marc Chagall." *Jardin des Arts*, no. 181 (December 1969): 42–51.

San Lazzaro, G. di, et al. "Hommage à Marc Chagall." Special number of *XXᵉ Siècle*, November 1969.

———. "Apothéose de Chagall." *XXᵉ Siècle* 34 (June 1970): 19–21.

———. "Chagall monumental." *XXᵉ Siècle* 36 (December 1974): 168.

Schapiro, Meyer, and Jean Wahl. "Marc Chagall: La Bible." *Verve*, nos. 33–34, 1956.

Schmidt, George. "Le Merveilleux dans l'art de Marc Chagall." In *Les Maîtres de la peinture française contemporaine*. Freiburg, West Germany: Kunstverein Freiburg, 1947.

Schneider, Daniel Edward. "Psychoanalytic Approach to the Painting of Marc Chagall." *College Art Journal* 6, no. 2 (1946): 115–24.

Schneider, P. "Marc Chagall." *Art International* 23 (Summer 1979): 97–102, 112.

Sorlier, Charles. "Chagall aujourd'hui." *Jardin des Arts*, no. 219 (July–August 1973): 48–56.

Verdet, André. "Farewell to Marc Chagall." *Artforum* 23 (Summer 1985): 85.

Vogelsanger-de Roche, I. "Chagall's Stained-Glass Windows in Zurich." *Graphis* 27, no. 158 (1971–72): 568–75, 603, 606.

Films

Harris, Charles. *Marc Chagall: The Colours of Passion*. International Film Bureau, 1979.

Kline, Herbert. *The Challenge: A Tribute to Modern Art*. New Line Cinema Corporation, 1976.

Olin, Chuck. *The Gift*. First National Bank of Chicago, 1975.

Rasky, Harry. *Homage to Chagall*. Kim International Corporation, 1977.

Index